MASKING UNMASKED

MAGING UNMASKED

MASKING UNMASKED

FOUR APPROACHES TO BASIC ACTING

ELI SIMON

First published 2003 by
PALGRAVE MACMILLAN™
175 Fifth Avenue, New York, N.Y. 10010 and
Houndmills, Basingstoke, Hampshire, England RG21 6XS.
Companies and representatives throughout the world.

PALGRAVE MACMILLAN is the global academic imprint
of the Palgrave Macmillan division of St. Martin's Press, LLC
and of Palgrave Macmillan Ltd. Macmillan® is a registered
trademark in the United States, United Kingdom and other
countries. Palgrave is a registered trademark in the European
Union and other countries.

ISBN 1-4039-6295-2 paperback

Library of Congress Cataloging-in-Publication Data
Simon, Eli.
 Masking unmasked : four approaches to basic acting / Eli
Simon.
 p. cm.
 ISBN 1-4039-6295-2 (pbk.)
 1. Acting. 2. Masks. I. Title.

PN2071.M37S56 2003
792'.028—dc21

 2003050573

A catalogue record for this book is available from the British
Library.

Design by Letra Libre, Inc.

First edition: November 2003
10 9 8 7 6 5 4 3 2 1

Printed in the United States of America.

This book is dedicated to Sabrina and Olivia

Acknowledgment

I wish to acknowledge and extend a heartfelt thanks to my colleagues and students in the Department of Drama at the University of California, Irvine.

Contents

Preface

This book, as the title implies, is designed to unmask basic principles of mask acting. My purpose is to share with you—actors, teachers, and mask enthusiasts—four systems of masking that significantly improve acting skills. Mask acting is not mysterious; fundamental techniques corroborate acting truths. I have tested and refined these techniques for fourteen years in the Department of Drama at the University of California, Irvine. In each of my undergraduate and graduate courses—including Clowning, Commedia, Physical Improvisation, Acting in Styles, and Character Transformation—masking promotes richly textured acting. The work evokes deeply personal responses that resonate on pragmatic artistic and aesthetic levels.

Working in masks strengthens traditional Stanislavsky-based methods of actor training such as specifying moments, pursuing objectives, articulating actions, listening and responding, and freeing creative impulses. In fact, these principles provide the same backbone for mask explorations that they do for scene work in well-made plays. Unlike realistic work, where the actor often spends weeks researching and "finding" a character, masked transformations are relatively instantaneous. Furthermore, mask acting fulfills the primary premise of acting: the comprehensive inhabitation of an "other." The work is designed to enhance an actor's range of playable characters. In doing so, actors are "stretched" in new directions. They experience heightened spontaneity, vulnerability, and truth.

In spite of this proven effectiveness, most theatre programs designate masking as an elective rather than a required course within core training. Mask classes often play runner-up to traditional acting approaches such as scene study, period styles, and auditioning techniques. There are understandable reasons for this. In some schools, the desire to mask exists but the masks themselves do not. In other cases, the masks exist but no one feels entirely qualified to dust them off and put them to use. And with masks, as with all creative endeavors, half-hearted attempts yield half-hearted results.

If you are interested in masking but don't own a set of acting masks, this book was written for you. You will find simple recipes for building functional masks. These will serve your needs for years to come. If you have a set of actor masks but aren't sure how to use them, this book was written for you. Each exercise is described in pragmatic terms. You will learn to use masks step by step. Your acting skills will increase at each new level of exploration. If this is your first sojourn into the world of masks, consider this a basic roadmap. If you are an experienced mask actor, the four approaches contained herein will augment your burgeoning skills. Let's put mask acting where it belongs: at the forefront of serious actor training.

INTRODUCTION

This book offers a detailed account of four mask acting systems: full-face (tragic) masks, bag masks, clowning, and half-face (commedia) masks. Each section is pedagogically designed to fortify basic acting skills. You may be wondering how your acting technique will be improved. What can you expect to learn by working in masks? To begin, it is important to understand that different sets of masks stimulate different areas of growth. Every masked journey involves multifarious experiences. Expect improvement in the following areas:

- Physical, vocal, and psychological transformation.
- Believability as an "other."
- Emotional availability.
- Passionate pursuit of objectives.
- Intensity of focus.
- Active choices.
- Ability to shift cleanly between actions.
- Detailed execution of activities.
- Strengthened imagination, playfulness, and creativity.
- Heightened impulses and reactivity.
- Creation of original monologues, scenes, and plays.
- Performance confidence.
- Connection with the audience.
- Ability to repeat discoveries.
- Ability to modify acting choices.
- Widened range of character roles.

I think you'll agree: This is a heady list of benefits. Still, most artists who are preparing to mask have questions regarding the substance

of the work. Certainly, many of these queries will be resolved in the process of masking. But, inasmuch as the work demands trust, there is value in addressing central concerns now, at the outset of the work.

MASKING QUESTIONS AND ANSWERS

1. *Am I just wearing a mask—or am I really acting?*
Great acting demands more than simply walking in someone else's shoes. Great acting demands inhabitation of shoes, skin, brain, breath, eyes, and heart. Masking promotes the comprehensive inhabitation of another being. This includes physical, emotional, vocal, and psychological transformation. You breathe new air. See with new eyes. Think new thoughts. Experience new needs. Working in masks prompts deeply motivated acting.

2. *Is it difficult to practice mask techniques?*
Masking is simple in theory and practice. All you need is an adequate space to work in, masks to wear, and a solid regimen to follow. You can work in groups or alone.

3. *Will I get lost in my emotions?*
Expect deep emotional responses. These emotions will be brought to bear on the work at hand. The exercises do not permit overindulgence in emotional states. Accomplished actors do not feel for the sake of feeling; their emotions rise and fall in accordance with objectives won or lost. In masks, feeling and doing also go hand in hand. Actors who use masks solely to emote are quickly reduced to an inactive puddle of tears.

4. *Does mask acting get boring? Do I have to stick with one mask for weeks on end?*
Some mask disciplines advocate a single-mask per actor approach wherein you are conjoined to that mask for the duration of the course. But this is not the law of the mask studio; there are as many

ways to act in masks as there are masks to act in. Acting skills are fortified by exposure to diverse families of masks. Diversification promotes creativity, spontaneity, and active choices. Masks are intrinsically theatrical. At the very least they are intriguing. At best they are mesmerizing. Boring? Never!

5. Will this be a spiritual journey?
There are many reasons people wear masks. Some are interested in contacting animal spirits. Others wish to worship gods. Certain mask cults continue to use masks as a means of communing with the souls of their ancestors. Indeed, masks have been used by numerous cultures—including ancient Mayans, Romans, Greeks, Native American Indians, and diverse Asian cultures—for the purpose of spiritual communion. These practices span thousands of years. But spirituality, in and of itself, does not promote good acting—the expressed purpose of this book. Therefore, while you may, on occasion, think you feel the spirit of the Great-Goddess-Mother-of-Theatre descending unto you, remember that the masking techniques described herein focus on building strong acting tools—not on becoming a swami.

6. I'm all thumbs—will I be able to make my own masks?
Building masks does take time but it isn't rocket science. With a minimum of guidance, even self-proclaimed "arts and crafts flunkies" can build a functional set of acting masks. Celluclay masks are light, strong, and actor-friendly. They can be shaped, sanded, adorned, and painted to suit your artistic taste and acting needs. They will serve you for years to come. *Please see appendix for mask building recipes.*

7. What experiences can I draw on?
You have probably been masking since you were a child. For example, if you went trick or treating on Halloween, you experienced the transformative power of masks. When you dropped into a mask—as Batman, the Lone Ranger, Frankenstein, a ghost—that character supplanted your primary identity. Given sufficient time to play in the

mask, you were able to realize the physical and vocal potential of your character. Thus, you shed your self and assumed an alternate identity. At the moment the mask was removed, you returned to your self. This, in a nutshell, demonstrated several inherent masking rewards: identity transformation, audience adulation (neighbors with candy), and power (tricks over non-masked scrooges).

8. Is this like putting on make-up?
Yes and no. Actors have used make-up to great effect throughout the ages. It is hard to imagine Marilyn Monroe without lipstick, Groucho Marx without his eyebrows, or the Cowardly Lion without whiskers. These are painted effects designed to merge and enhance the actor's individual expressions. Masks differ from make-up because they provide an entire surface that covers part or all of the face. This surface frees the actor from having to generate normal communicative facial expressions. Released from this responsibility, actors concentrate on other tasks, including heightened levels of physical, vocal, and psychological transformation.

9. Is it possible to incorporate masks into scripted material?
It's actually quite easy to combine masks and scripts. You can use scripts as a launching point, or begin with a set of masks to create original scenes and plays. In the exercises that follow, you will approach the work from both perspectives.

10. Can I apply my mask characters to other roles?
Discoveries garnered in masks can be applied to roles in non-masked plays. You can use masks to develop entire characters or incorporate specific aspects of the work—for example, walk, stance, voice, or gesture.

11. Will I be able to repeat my discoveries?
Masking should run like a well-tuned car. When you turn the key (drop into mask) the engine should start—*every* time. If your acting

engine operates now and then, you are not dependable. Directors, fellow actors, and audiences are distrustful of actors who perform in fits and starts. In or out of mask, you should strive to have all cylinders firing at every rehearsal and every performance. The good news is that masking results *are* repeatable. Revisiting specific masks guarantees specific results (after all, the mask does not change). Active journaling strengthens your ability to repeat with precision.

FROM MASK TO HU-MASK

In the interest of clarity, and to avoid general confusion as you read the book, let's clarify the differences between masks and Hu-Masks.

Before you put on a mask it is not inhabited, not alive, and therefore not yet a Hu-Mask (a human in a mask). At the precise moment you drop into character, the mask becomes a Hu-Mask. The genesis of transformation also marks the genesis of discovery. This is when you begin to discover the Hu-Mask's unique traits. Each Hu-Mask breathes, thinks, moves, and vocalizes in unique ways. It is impossible to predict these characteristics until the mask—through you—becomes a Hu-Mask.

Giving birth to a Hu-Mask does not negate or supplant your own consciousness. You, as actor, remain aware of your involvement in the work. In essence, both you and the Hu-Mask are alive simultaneously. Think of yourself as a medium through which the Hu-Mask is expressed. Each Hu-Mask is capable of experiencing deep feelings and needs. But, in reality, *you* are the being that experiences those emotions and desires. This happens without your having to dictate instructions to the Hu-Mask. In fact, little is gained by doing so. In order to fully experience a Hu-Mask, you must initially commit yourself to following its lead. Battling the Hu-Mask for control of the work negates meaningful discoveries. Respecting the Hu-Mask's individualized power leads to heightened levels of transformation and truth.

ACTOR APPROACH

Openness

Work with careful determination. Your acting skills will improve step by step. Know that these steps will be uneven. Sometimes you'll leap. Sometimes you'll hop. Regardless of your progress, bring to each step an open mind. Maintain a high level of integrity. Drop any preconceptions you may have about masking. Don't worry about what will happen next. Trust the masks and yourself.

Positivism

Enjoy yourself. Mask acting should never feel like a chore. It's a pleasure to discover the unique attributes of a new mask, or to re-experience the power of a Hu-Mask you know. Having fun does not negate a strong commitment to the exercises. You will find that a rich enjoyment of process deepens your focus on the exercise at hand. Maintain genuine support both for your own discoveries and those of your peers. A studio filled with positive artists supports high-level learning.

Focus

Each exercise is introduced with an overview of actor objectives. Clarify these objectives before engaging in the work. This will assist you in properly focusing your energy. For example, bag masking strengthens shifting, character creation, and audience connection. At first, you will focus on one objective at a time. As you layer objectives, your focus changes accordingly. This enables you to merge divergent acting skills. In time, multifocusing becomes second nature.

Curiosity

Consider yourself a Hu-Mask scientist. Retain an innate sense of curiosity about each experiment/exercise. Try to avoid predicting where you will be led, what you will discover, and who you will be-

come. Instantaneous discoveries—supported by a focused, positive, and open approach—occur when least expected.

FOUR FAMILIES OF MASKS

The four families of masks follow a logical order. Exercises build sequentially—newly acquired techniques lead directly to more advanced challenges. Start at the beginning of a chosen chapter and move through the exercises in order. Foundation, core, advanced, and applied exercises are so designated. If you are engaging in an overview of multiple chapters, complete core exercises before switching masks.

The salient features of each family of masks are as follows:

Chapter One: Full-Face Masks

- Physical and vocal transformation
- Emotional and psychological connection to character
- Basic stance, walk, gesture, and voice
- Merging activities with character need
- Repetition and modification of discoveries
- Informing non-masked characters
- Group play
- Applied: Greek tragedy

Full-face masking centers on comprehensive transformation. This is a logical starting point for acting in masks. You will experience a heightened sense of physical, vocal, emotional, and psychological change. Once transformed, it is possible to explore simple activities with tremendous attention to detail. Your enhanced ability to transform is applicable to subsequent sets of masks.

Chapter Two: Bag Masks

- Creating new masks
- Using known and imagined characters as source material

- Developing original scripts
- Physical and vocal expressiveness
- Shifting with clarity
- Bold choices
- Applied: Story-telling jokes and complex scripts

Bag masks provide a perfect transition from full-face masks to clowning. You must shift cleanly between multiple characters while maintaining precise physical and vocal control. In addition, you write scripts, create masks, and perform a wide variety of characters.

Chapter Three: Clowning

- Pinpointing unique clown persona
- Nonverbal performance skills
- Risk, failure, high stakes, and vulnerability
- Improvised routines
- Performance confidence
- Connection with the audience
- Original acts
- Applied: Duo entertainments

The central goal of clowning is to find and refine your singular clown persona. Clowns are not only funny—they can also be sad, brilliant, stupid, pathetic, and poignant. Whereas full-face masks encourage introspection, clowning is playful in nature. Thus, using divergent sets of masks, you will inhabit both tragic and comic characters, each with a dynamic set of needs, actions, and activities.

Chapter Four: Half-Face Masks

- Heightening spontaneity and play
- Wide variety of character types
- Instant transformation

- Improvisation skill
- Working from scripts
- Developing lazzi and scenes
- Building and holding an audience
- Applied: Original commedia

Half-face masks are based on a technique called instant transformation. The work is quick, bawdy, and daring. Your collection of character types is continually broadened. The work incorporates eclectic costumes, props, and wigs. Original scenes and comic routines are developed through improvisation and audience interaction.

USING THE BOOK

Roughly speaking, there are two ways to use this book. You can explore one genre of masking by focusing your efforts within a single chapter. Or you can explore two or more sets of masks at once, combining exercises in different chapters. Choosing your methodology is a matter of deciding what best serves your acting needs and how much time you can dedicate to the process.

Option 1: One Chapter of Masking

- Complete foundation, core, advanced, and applied exercises
- Study intensively within that genre of masking
- Gain a comprehensive understanding of specific masking techniques
- Aquire a foundation for work in other sets of masks
- Repeat exercises, as necessary

Option 2: Combining Chapters

- Complete foundation and core exercises within each chapter
- Shift directly between divergent sets of masks

- Experience constant stimulation and evolving challenges
- Perform in scripted and improvised works

A guiding principle of this book is diversification. If possible, jump freely from clowning to bagging, or from full-face to half-face. You will find that one set of masks corroborates a different set in powerful, unexpected ways. For example, bag mask performances link the depth of full-face transformations with the clown's imaginative play. Clowning draws on the comic zaniness of half-masks and the precise shifts of bagging. Thus, acting techniques used in one type of mask resurface and resonate anew in the next set. Cross-referencing masks establishes a flow of stimuli that enriches the learning process.

Whether you decide on option one or option two, it's best to plan meticulously. If you are planning to combine families of masks, focus on core exercises in each section. These are clearly noted. Establish goals for each specific masking session. That said, remain as flexible as possible. If you are making noteworthy strides in a particular section, spend an extra hour or two exploring those masks before moving on. But be forewarned: Multiple mask play often evolves into single mask play; each mask is a potential source of fascination that warrants ongoing investigation.

VALIDATION

After each exercise, take time to discuss discoveries. Suggested topics for discussions are included. Be honest. Be concise. Validate skills that you and your peers have acquired.

JOURNALING

Actors often equate working in masks (especially full-face masks) with dreaming. In the process of becoming a Hu-Mask, actors enter trancelike states of being. Immediate imagery is vivid. However, as with dreams, details become blurred with time. This is one reason it's

sound practice to keep an ongoing account of your mask explorations. Why risk the chance of forgetting cogent breakthroughs? Journaling also provides needed respites from the rigors of transformation; nonstop masking is exhausting.

Bring a spiral notebook to the studio. After each exercise, designate three to five minutes for journaling. Dedicate a minimum of one page per mask. You will find that committing your discoveries to paper solidifies the experience in your mind's eye. This provides a means of accurately reconnecting with that mask; notations act as triggers. For example, let's assume you've lost the Hu-Mask's walk. You refer to your notes. "Bow-legged, feet splayed, quick tempo, slight lift." Presto: the walk remembered.

The following one-page sample journal chart is designed to assist in the organization of journal entries. Be as specific as possible. *Please see appendix for blank chart.*

Hu-Mask Characters—Sample Journal Chart

Mask number: 27

Name: Hodie **Age:** 5 **Gender:** M

Key triggers: Paint sheen. Looking from right to left. Memory of mom.

Facial characteristics: Twisted mouth, high forehead, bump on right cheek.

Physical characteristics

Head: Tilted to the left. Held high. **Hands:** Constantly tapping.

Feet: Pointed inward. **Torso:** Lifted, long, forward tilt.

Shoulders: Slumped and relaxed. **Other:** Knees locked, arms swing.

Walk: Hesitant herky-jerky pattern. The feet feel unstable. Leading from knees.

Gestures: Likes to wave at people with one arm raised above the head.

Voice: High, squeaky pitch. Speaks quickly. Not sure of words at first.

Language: Thinks and speaks in French. Very rudimentary.

Central Need: To please others and say hello.

Activities: Waving at people he sees.

Relationship with other(s): Wants to be loved. Has been kicked out of the nest.

Emotions: Happy when contact is made. Sad when alone (often).

Thoughts: Can I get that person to acknowledge me? Will I ever be loved?

Environment or surroundings: Rural scenes. A road by the side of the forest.

Additional thoughts: Hodie alternates between being a have and a have-not. Many people ignore him but he never gives up trying to connect. He wants to be adopted. He is often hungry but doesn't have any food. The cloak needs to wrap around shoulders.

Notes on journal notes

Name. If you don't know the name, simply describe the mask.

Age. Masks can be timeless. Others are simply "teenagers" or "ancients."

Gender. Some masks are genderless or move between genders.

Key triggers. Describe sensory input that instigated transformation.

Facial characteristics. These refer to the mask's and yours.

Physical characteristics. Be specific when describing each part of the body.

Walk. Be specific about the feet, arms, and weight placement.

Gestures. Describe in detail.

Voice. This includes pitch, placement, and tempo.

Language. What language did you think in? Speak in?

Central need. What were you trying to accomplish?

Activities. Write about what you tended to do, unprompted.

Relationships. How did you interact with other characters?

Emotions. Note feelings evoked by the work.

Thoughts. What were you thinking about, unprompted?

Environment or surroundings. Where were you and what could you see?

Additional thoughts. Note other discoveries germane to this mask.

When to Journal

It is best to journal immediately after rolling out of mask. If you wait to journal until you have inhabited several Hu-Masks, differentiating

between them becomes difficult. Take the time you need to write about full-face Hu-Masks. Work quickly when journaling about half-face Hu-Masks. Critical data should be recorded right away. You can always return to your journal and flesh out descriptions later in the day. Accurate journaling takes practice. Pay attention to details and be precise.

BUILDING MASKS

You will find detailed instructions in the appendix for full-face, half-face, and bag mask construction. Obviously, you'll want to build (or otherwise acquire) your masks before embarking on a course of study in them. Actors who build masks experience a deep connectedness with these "children," especially when working in them. Indeed, building masks is a bit like giving birth—you love your creations regardless of their intrinsic beauty. There is a deeper sense than just ownership; the masks become theatrical family. It is an act of generosity to share your masks with fellow actors. And it's an act of friendship to fill another actor's mask with your breath, eyes, mind, and heart.

HANDLING MASKS

Masks are durable acting tools and expect wear and tear, but they must always be handled with care. For example, do not toss them on their faces. Avoid dropping them on the floor. And never run face-first into walls while wearing a mask. Think of uninhabited masks as potential Hu-Masks. Approach them with respect; coupled with your creative power, they can transform your acting forever.

IN SUM

Masking addresses essential aspects of acting technique. It couples transformation with believability, active shifting with imaginative choices, and risk with vulnerability. Each discovery may be used in

whole or part to build future roles. Performances are repeatable. Ongoing explorations stretch your range of playable characters. Add three cups of passion. Prepare to become a more versatile and resilient actor.

FULL-FACE MASKS

OVERVIEW

A characterization is the mask which hides the actor-individual. Protected by it he can lay bare his soul down to the last intimate detail.
　　　　　　　　　　—*Stanislavski,* Building a Character

Full-face masking fulfills a fundamental goal of high-level acting: the comprehensive inhabitation of an "other." This involves much more than just walking in someone else's shoes. In addition to that new walk, you experience profound emotional and psychological change. You think foreign thoughts, speak strange languages, and remember alternate histories. Your body is shaped by divergent energies. Thus, you become more than just an actor wearing a mask—you become someone else, experiencing that otherness in the marrow of your bones.

Whereas in standard theatrical productions we often rehearse for weeks before finding the essence of our character, full-face masking begins with transformation and proceeds from there. Your new character, or Hu-Mask, is alive within you from day one. Indeed, as you will soon experience, the Hu-Mask dictates needs, actions, emotions, and activities. This releases you from the burden of figuring out

who, what, where, when, and why. It further negates the necessity of fitting a character into those logical givens. Exploring the Hu-Mask—and letting the Hu-Mask explore you—illuminates performance truths. Even simple activities—tying string, collecting junk, or singing songs—become sources of intense fascination. All that is required of you is an open mind and a willing heart.

TERMINOLOGY

A *mask* is the object that covers part or all of your face.

A *Hu-Mask* is the character you become—a human in a mask.

Transformation refers to the change in your thoughts, actions, voice, and body when you shift from an actor in a mask to a Hu-Mask.

Triggers are sensory stimuli that initiate masked transformations.

Dropping in refers to the moment you put on the mask and begin the process of transformation.

Dropping out refers to the moment you take off the mask and return to your self.

Neutral-ready is your state of alert relaxation prior to dropping in and after dropping out of mask.

The *standing line* is where you stand before dropping into mask—three feet from mirror.

Shifting denotes a change in your acting. Shifts are physical, vocal, physiological, or emotional in nature. Shifts also alter the tempo and intensity of a scene.

An *objective* is what the Hu-Mask wants.

An *action* is the way the Hu-Mask attempts to fulfill the objective.

An *activity* is what the Hu-Mask does (knit, sew, crumple paper, skip, sing, etc.).

ALL-POWERFUL MASKS

Masks are simple objects that cover your face. Yet they are capable of instigating transformative experiences. This is why so many actors, teachers, and directors—including Aeschylus, Shakespeare, Brecht,

Grotowski, and Artaud—speak of masks as all-powerful objects. It is worth remembering that masks are not innately powerful. We imbue them with power in order to reap the benefits of transformative action. This is a convenient construct—and it works. The truth is that *you* are the medium through which each facet of masked magic occurs. Without your artistic creativity and talent the mask might as well decorate a wall. Without you, a mask would never become a Hu-Mask.

TRANSFORMATION

Transformation n. *A thorough or dramatic change in form or appearance.*
—The New Oxford American Dictionary, *2001*

Why are full-face masks transformational? For starters, they cover your entire face. Facial expressions are our primary means of establishing identification. We learn this at a tender age. As babies we gauge love, trust, and understanding by scrutinizing parental visages. By the time we are toddlers, we read meaning in each wrinkle, wart, and pore. Full-face masks completely alter our facial characteristics so that, in a very real sense, transformation occurs the moment the mask is donned. When you look at yourself in a mask, and when others look at you, the "you" that is normally there has vanished. You have been replaced by a new being. How? Your face has changed. Physical and vocal traits—along with habits, thoughts, and emotions—quickly follow suit. In the blink of an eye, a full-face mask replaces you with someone else.

DREAM STATE

Imagination is more important than knowledge.
—*Albert Einstein*

With practice and patience, full-face masking often seems like dreaming. As in dreams, Hu-Masks take mysterious turns at unexpected

times. We empower them to introduce new realms of thought and expression. Thus, you will often sense that you cannot control the flow of action and are being led from one event to another. In addition, you become so deeply immersed in the work that your sense of time is altered. It may seem as though you have been masking for hours when, in reality, only five minutes have passed. Conversely, half an hour seems like half a minute. As you become attuned to your Hu-Mask, you experience the truth of a new persona—just as you perceive truths while dreaming. Nothing contradicts these perceptions until you "wake up," or return to your non-masked self. If this sounds frighteningly hypnotic, do not worry—entering a dream state does not mean you have been possessed by demonic powers. It is simply that your conscious thoughts are not required to regulate the work. The Hu-Mask is in the driver's seat, leaving you free to unleash creative instincts. You will snap out of the dream state the moment you drop out of mask.

WHAT, ARE YOU CRAZY?

Will you lose yourself in powerful full-face transformations? Yes and no. You will undoubtedly experience a deep connection with the characters you are playing. But, at the same time, you retain awareness of the fact that you are working in a mask. Sometimes the differentiation between *being* an other and *playing* the other are acute. Sometimes the two (of you) merge, creating a seamless duality. This duality is worth striving for in every acting assignment you undertake; it is an underlying premise of top-flight acting.

In any event, there is no need to fear the onset of schizophrenia. Everything you learn in full-face masks is based on proven technique. Becoming someone else—in masks as in non-masked acting—is not a test of sanity. If you fall into a dark pit filled with screaming voices, you can always end the nightmare by taking the mask off your face.

ONCE AGAIN, WITH FEELING

Masked moments, like all important acting discoveries, must be repeatable. If you cannot repeat your work, you must rely on dumb luck to pull you through. Nobody trusts an actor than can only get it right every now and then. High-level masking, like great acting, is organized to ensure repeatability. Full-face exercises permit you to understand, retain, and repeat each step of the acting process—from triggers to transformation to action. The work is therefore controllable, repeatable, and sustainable. Revisiting Hu-Masks reconnects you with prior discoveries and provides options for further investigation.

PRE-MASK FOUNDATION EXERCISES

Prior to each day's exercises, take time to engage in a thorough physical and vocal warm-up. A comprehensive warm-up prepares your body, voice, and mind to respond to creative ideas and impulses. It also reduces the risk of injury to tight muscles, ligaments, and vocal chords. Once you are warmed-up you will be able to mask utilizing the full extent of your instrument.

In the following warm-up, each physical exertion is accompanied by a vocal task. Warm-up with integrity. This means really *doing* each phase of the warm-up, not just marking time until masking begins. Focusing now will support mask transformation later.

Exercise 1.1: Warm-Up
fifteen minutes

1. Begin by standing in a circle. Look around the circle and see who is there.
2. Breathe easily in neutral-ready and make sure your body is relaxed and aligned.
3. Shake out your hands. AAAAAAAAAAAAAHHHHHHH

4. Shake out your arms. Trill: BBBBBBBBBBBBBBBBBB
5. Shake out your legs. EEEEEEEEEEEEEEEEEEEEEEE
6. Shake out your feet. OOOOOOOOOOOOOOOOOOOO
7. Circle your feet. UUUUUUUUUUUUUUUUUUUUUU
8. Circle legs. MMMMMMMMMMMMMMMMMMMMMM
9. Circle hips. NNNNNNNNNNNNNNNNNNNNNNNNN
10. Circle torso. HHHHHHHHHHHHHMMMMMMMMMMMM
11. Circle shoulders forward. ONE BY ONE BY ONE
12. Circle shoulders backward. TWO BY TWO BY TWO
13. Jog in place. AAAAAAAAAAAAAHHHHHHHHHHHH
14. Bounce on your toes. BUBBLY BUBBLY BUBBLY
15. Stretch in all directions. Hum and chew
16. All jog around the studio. WAZZA WAZZA WAZZA
17. Roll down the spine. OOOOOOOOOOOHHHHHHHHHH
18. Roll up the spine. Breathe deeply throughout
19. Pound out the body. AAAAAAAAAAAAAAHHHHHHH
20. Stretch whatever feels tight. Hum and chew, again
21. Find neutral-ready stance, breathe, and relax.
22. Look around the circle, breathe, and sigh.
23. Say to one another:
 Person 1. Hello _____ are you here?
 Person 2. Yes, _____ I am here, ready to work.
 Person 3. Hello _____are you here?
 (Continue until everyone has spoken.)

Add additional warm-ups and stretches, time permitting.

A note: Rolling up and down the spine prepares you for rolling up when you are ready to transform in mask and rolling back down into neutral ready. To roll up, begin by squatting with your arms relaxed on top of your thighs. Your head is bent toward the floor. Breathe deeply. Lift your buttocks up, remaining bent over at the waist. Beginning at the base of your spine, unfurl your spine slowly, leaving your head heavy and hanging toward the floor. Slowly stack your vertebrae as you come to a standing position. Your head is the

last part of your body to come into alignment as you stand in neu-tral-ready. To roll down, reverse this process, beginning by dropping the head forward.

TRIGGERING EXERCISES

Trigger n. *An event or thing that causes something to happen.*
—The New Oxford American Dictionary, *2001*

Your senses—seeing, hearing, touching, tasting, and smelling—cou-pled with active imagination initiate mask transformations. This is called "triggering"—a powerful means of "working from the out-side-in." Typically, transformations begin with body, move to voice, and then incorporate thoughts, needs, and emotions. In order to gen-erate powerful full-face mask transformations you must open your senses to external stimuli and act accordingly. Practicing these tech-niques paves the way for compelling mask transformations. Eventu-ally, how those masks look on your face, feel pressed against your skin, and smell when you breathe through them will profoundly af-fect the quality and direction of your work.

Sight is a primary source of sensory information. We gather and process visual information throughout our waking hours. Even in dreams, visions take center stage. Your work with a mask begins when you pick it up and look at it. Doing so awakens powerful visual triggers. It's important to remain aware of these early impressions; they fuel initial transformations.

Eliminating sight heightens the other four senses. Close your eyes for two minutes, right now, and listen to the sounds around you. You may notice that your sense of hearing is immediately height-ened. You become aware of myriad noises you did not hear when your primary sense (sight) was focused on reading this page. Thus, by minimizing sight, you maximize your ability to trigger with your other four senses.

Exercise 1.2: Touch Trigger → Physicalization
ten minutes

Becoming connected to the outer world through diligent sensory exploration heightens awareness of outside triggers. Once this awareness is peaked, triggering powerful transformations is second nature. We begin our work with the sense of touch. Take what you get when touching and exploring. The work is deeply personal; do not try to shape results in order to gain approval. Bring yourself into alignment with your sense of the trigger. Your senses may make sense and, then again, they may not.

1. Find a small object from nature—for example, a twig, flower, leaf, or rock.
2. Sit quietly in neutral-ready, holding the object, and close your eyes.
3. Explore the object for five minutes using your sense of touch.
4. Put the object down, lie on the floor, and close your eyes.
5. Bring the object and the sense of touch back to mind.
6. When you are ready, roll yourself up into your sense of touch. Put the essence of your observation in your body.
7. Allow yourself to move according to your sense of touch.
8. Roll down to the floor and relax in neutral-ready.
9. Take time to journal about your discoveries.

Discussion
- What did you get when you touched the object? What qualities did the object yield?
- How did those qualities affect you?
- In what ways were you changed when you rolled up?
- What surprises did you encounter when physicalizing the object?
- Were you able to sustain the sense of touch throughout the exercise?

This exercise (and all sensory exercises) can be repeated with new objects.

Exercise 1.3: Sound Trigger → Vocalization
ten minutes

It is important to encourage vocalization—otherwise you may fall into the habit of generating mute characters. To this end, focus on using a trigger to instigate vocal transformation. As you begin vocalizing, find sounds that are true to the object you are using. Do not be overly concerned with creating complete sentences. It is possible you will not use words at all. Focus instead on forming sounds.

1. Lie down holding your object.
2. Close your eyes and relax into neutral-ready. Breathe deeply and clear your mind. Check to make sure your body is aligned and relaxed.
3. Explore the object using your sense of hearing.
 A. Shake the object.
 B. Tap it.
 C. Move it back and forth near your ear.
4. Focus on a sound (or series of sounds).
5. Vocalize sounds that capture the essence of your object.
6. Roll up to your feet and continue vocalizing for a few minutes.
7. Roll back down and relax in neutral-ready.
8. Take a moment to journal about your discoveries.

Discussion
- How was your sense of hearing affected?
- What qualities did you take from the object?
- How were you able to transfer triggers into vocalizations?

Exercise 1.4: Merging Triggers → Comprehensive Character
twenty minutes

You can merge body and voice in two ways: (1) With a single trigger that works on both levels and (2) by combining different triggers—one for body and one for voice. Let's focus on the two-trigger method; in all probability, you will be working with divergent sources of stimuli in masks. To start, focus on the same objects/triggers utilized in exercises two and three. If at any time you lose your sense of a trigger, go back to the object and reconnect with it.

1. Return to your objects and sit comfortably in a chair or lie on the floor.
2. Take time to relax your mind and body in neutral-ready.
3. Re-explore your sense of touch with the first object.
4. Now roll up and find the movement of your first exploration.
5. Roll back down to the floor and re-explore sound with the second object.
6. Now roll up and find the vocalization of your second exploration.
7. Roll back down.
8. Roll up and physicalize again.
9. Add vocalizations as you continue to move about the studio.
10. Allow your movement and vocalization to merge into one character.
11. Roll back down into neutral-ready and relax.

Discussion
- Were you able to combine the two triggers?
- How was your transformation affected by the combination?
- Would you keep these two together or separate them for future use?

You may have been surprised to discover how effortlessly body and voice converged. Keep in mind that these were random choices. There are countless additional outside-in trigger possibilities. You

can use objects that fulfill the specific nature of a character you are playing. Each object—whether man-made or from nature—can be explored at home, brought to rehearsals, or stowed in your dressing room. They are there for you when you need them.

MODIFYING RESULTS

Masking provides ongoing opportunities to explore extreme character choices. During preparation exercises and when you are exploring a specific Hu-Mask, you will undoubtedly experience extreme energy placement:

A. High energy

- Screaming and wailing
- Racked with physical tension
- Pushing for results

Range chart—high energy

LOW	1	2	3	4	5	6	7	**_8_**	**_9_**	**_10_**	HIGH

B. Low energy

- Whispering or silent
- Lacking integrity
- Unmotivated by needs

Range chart—low energy

LOW	**_1_**	**_2_**	**_3_**	4	5	6	7	8	9	10	HIGH

C. Middle Energy

- Easily heard and understood
- Body relaxed and alert
- Appropriately motivated by needs

Range chart—mid-range energy

LOW	1	2	3	_**4**_	_**5**_	_**6**_	_**7**_	8	9	10	HIGH

Your mid-range provides a platform for sustainable, communicable choices. This is a viable place to begin character exploration, allowing energy to lift or drop according to given circumstances, needs, and interaction with others.

Accessing your mid-range does not imply that you should avoid high- or low- range choices. You must be physically, vocally, and emotionally capable of sustaining high and low energy. Thus, you are limited if you can only access your mid-range, just as you are limited if you can only scream or whisper. You must sustain believability when yelling at the top of your lungs. And you must sustain intensity when whispering. Masking allows you to explore both extremes and to practice shifting between them. Later, when you remove the mask you can continue to modify results in order to meet the external objectives imposed by your script, acting partners, or director.

To begin the process of modification, assess your initial transformation. Was it truthful, believable, and playable? Were you over the top? Just scratching the surface? Use the following two exercises to practice energy modification.

Exercise 1.5: Maximizing
fifteen minutes

Let's say you have discovered an intriguing means of movement, triggered by touch. It is heartfelt but plays small. Nobody sitting more than three feet away can figure out who you are or what you are doing. Your efforts are at the 1 to 2 level.

1. Reconnect with your physical trigger.
2. Roll yourself up to your feet and reestablish a small walk, level 1.
3. Maximize the walk to 4.
4. Maximize to 6, then 8.

5. Continue to maximize the walk until your entire body is at level 10. Try to maintain believability even at this heightened level.
6. Now slowly bring your movements back to middle ground, 4–6.
7. Explore and sustain physical expression at each level: 2, 4, 6, 8, and 10.
8. Roll down into neutral-ready and relax.

Discussion

- Were you believable at all levels?
- What level was most appropriate for this emerging character?
- Was your middle range changed by going to extremes and coming back?

The same system of maximizing works for vocalization. Be sure that you warm-up, breathe deeply, and fully support your breath. Do not hurt yourself screaming.

Exercise 1.6: Minimizing
fifteen minutes
In this case, imagine you have found a vocal pattern that is too large to sustain—8 to 9 on the energy scale. Support your breath. This will protect your voice at higher levels and ensure that you can be heard at lower levels.

1. Reconnect with your trigger.
2. Roll yourself up to your feet and reestablish your vocal pattern.
3. Lift it to level 10.
4. Now begin to minimize the pattern to level 8.
5. Continue minimizing your vocal placement to levels 6, 4, and 2.
6. Allow your vocality to become so subtle you can barely be heard, level 1.
7. Explore and sustain physical expression at each level: 10, 8, 6, 4, and 2.

8. Roll down into neutral-ready and relax.

Discussion
- Did concentrated effort allow you to adjust your choices?
- In what ways were you able to tuck away the work?
- Did this deepen or weaken believability?
- Were you able to sustain connection and truth?

This completes preparation for acting in full-face masks. Your senses are primed to trigger body and voice. You are able to merge triggers, as needed. As you proceed into the heart of transformation, remember that every honest discovery can be maximized, minimized, or left alone. Avoid pushing for results. Forced transformations are synonymous with forced acting moments: unbelievable. Your work will be richly rewarded if you trust your ability to trigger, take what you get, and transform accordingly.

SETTING UP FOR FULL-FACE MASKING

BUILDING THE MASKS

Building a set of full-face masks is not a daunting task. Working together, a group of actors can construct a usable family of masks in a matter of days. There are intrinsic rewards in building your own masks as opposed to buying them from an independent vendor. You know your own masks inside and out. Your imagination is piqued during the process of design and construction. And it is empowering to breathe life into a mask you created. Transformation completes a cycle of creative artistry. *Please see appendix for instructions regarding the construction of your own set of full-face masks.*

STUDIO SET-UP

Keep a tidy studio for this section of masking. Distractions—masks strewn about, backpacks flung on the floor, half-eaten food on

chairs—negatively impact the work. Take time to sweep the floors, stow books, and arrange chairs in an orderly manner. Turn off cell phones and pagers.

MIRRORS

Mirrors play an important role in full-face masking. Ideally, the studio should have a bank of mirrors on one wall. Dance studios provide perfect spaces (although you won't need a barre). Take time to clean the mirrors. Smudges and streaks alter images.

CLOTHES

Actors wear dark sweat clothes. These should not be skintight leotards. Rather, wear comfortable, loose-fitting sweatshirts and pants that fully cover your arms and legs. Black or gray is best. Avoid clothing with lettering or logos.

HAIR

The length of your hair is relatively unimportant. You'll be using wigs. That said, long hair can be an asset when employed for certain Hu-Masks. You will quickly discover whether long hair is a positive addition or a hindrance. If your Hu-Mask is derailed by long hair then your flowing tresses must be hidden from view. Bring an ample supply of hair bands, combs, and clips.

WIGS

Wigs are powerful transformers and, like masks, can be used as primary triggers for new characters. They can entirely alter your appearance. We use them in this section to compliment your masked visage. It's best to collect fifteen to twenty wigs. These should offer a wide array of styles and colors: long, medium, and short; blonde, black, brown, white, red, and gray. My collection is

comprised of throw-aways from the costume shop and bargain bin cheapos culled from thrift stores. Comb a few. Leave the rest scraggly.

CLOAKS

Each actor needs one plain, dark cloak. The material should have weight—old army blankets are perfect. Cut out head holes if needed. Cloaks must be large enough to support a variety of uses:

- Draped over the shoulders like capes.
- Slung turban-style around the head.
- Looped around the waist as a belt.
- Pulled between the legs like an oversized diaper.

THE STANDING LINE

Tape a parallel line on the floor three feet from the mirrored wall. When you are ready to transform, stand on this line facing away from the bank of mirrors. Put on the mask. Adjust hair and mask straps. Turn around to face the mirror. Make primary adjustments when you see your image reflected in the mirror. Proceed with the exercise.

THREE TABLES

Place three tables in the studio on the opposite wall from the mirrors. One table displays masks. The second holds wigs. The third is for props.

WATCHERS

Actors should be watchers as well as maskers. There is intrinsic value in observing peers transform in masks. Creativity is heightened when

shifting between doing and watching. Teachers are also watchers—they monitor exercises, keep the space safe, and offer side coaching when necessary.

Hu-Masks are usually aware that they are being watched. They do not seem to mind. However, they instinctively prefer to interact with other Hu-Masks. These are like-minded members of their family. They share an attraction to simple games and activities. And they seem to intrinsically understand one another. Full-face masks rarely attempt to interact with watchers. If you are watching, do not take this personally. Fulfill your job: Watch and learn.

A reminder: It's best to limit the number of actors working in masks to eight. For a group of sixteen actors (an ideal size for training purposes) divide the group in half—eight watchers and eight maskers.

CORE EXERCISES: ACTING IN FULL-FACE MASKS

Initial exercises with full-face masks rely on heightened sensory awareness. Avoid the temptation to push for results. Forced transformations beget false steps and bogus moments. Trigger honestly by leaving your senses open to each mask you use.

Warm-up reminder: Before dropping into these (and all) masks be sure to engage in a thorough warm-up (exercise 1.1). Keep in mind that this family of Hu-Masks is reluctant to verbalize. Warming your voice stimulates vocal responsiveness.

Exercise 1.7: First Impressions
fifteen minutes per mask
Full-face masks instigate artistic creativity the moment initial observation begins. Formative work commences with visual triggers. You look at the mask—the mask looks at you. Ideas, environments, voices, and stories are stirred. These initial observations, rich with imagery and impulse, lead to truthful transformations. Be prepared: you may experience evocative responses to the mask. Allow those

responses to resonate within you. Each image, idea, and emotion carries the potential to inform your choices.

1. Lie on your back, feet flat on the floor, knees raised, and close your eyes.
2. Take a moment to find neutral-ready: Relax your mind and body. Scan your thoughts and let them go. Check to make sure your spine is aligned. Breathe deeply.
3. Masks are placed on the actors' chests—looking up, chin to chin.
4. Open your eyes slowly.
5. Move the mask slowly so that it:
 A. Looks up at you.
 B. Peers down at you.
 C. Looks at you from the left.
 D. Looks at you from the right.
6. Allow light and shadow to plays across the mask's features.
7. Lie back down and place the mask on your chest.
8. Breathe and relax in neutral-ready.
9. Review visual observations in your mind's eye. Journal.

Discussion
- What flashed through your mind when you first looked at the mask?
- Did the mask change attitude when shifted to different angles?
- Did the mask yield a sense of gender? Place? Age?
- Did you get a name?
- How did the mask affect you?
- Did you sense a need to do something?
- Was there a story waiting to be told?

It's amazing how much information can be garnered through mask observation. You may have noticed strong emotions rising. You may also have felt that you were somewhere else, projecting envi-

ronments into the studio. Take time to journal about your discoveries. If you are short on time, jot down idea headings and fill in pertinent descriptions later; details come in waves once the work is completed.

STRONG EMOTION AHEAD

Emotion n. *A natural instinctive state of mind deriving from one's circumstances, mood, or relationships with others.*
—The New Oxford American Dictionary, *2001.*

Full-face masks often induce intense emotional responses. Thoughts run near the surface but feelings run deep. These emotions leap between joy and sadness, pleasure and anger, and jealousy and love. Emotional surges occur during every facet of the work—when viewing the masks, wearing them, or reviewing exercises. Sometimes an actor will break down and weep uncontrollably during mask selection. This continues throughout the exercise. If the actor so much as looks at the mask, sadness resurfaces. Other feelings—anger, frustration, or sensuality—also manifest unexpectedly. Emotional responses are often attributable to submerged feelings evoked by the qualities of the mask's face. Perhaps the mask resembles a family member that has died. A lost lover's wink resides in the creases. A trusted friend has that same mole. Allow emotions to wash through you; blocked feelings stymie honest reactions.

Feel free to stop working with a mask that instigates overwhelming emotional responses. Experiencing emotion, in and of itself, does not achieve the objectives of the work. If all you can manage to do is sit in a corner and cry, get out of the mask as soon as possible. Do not fall prey to over-emotionality; mask acting is not drama therapy. Sob for a minute or two and then find a new mask to work with. Your emotional state should shift from mask to mask.

Having been forewarned about the dangers of emotional indulgence, continue transforming into high-emotion Hu-Masks if it is not overwhelming to do so. Ultimately, as a well-rounded actor, you must conquer high-emotion scenes; these are a mark of excellence for successful working actors. Full-face masking provides opportunities to play high emotion without falling prey to it. In every instance, you must work *through* the Hu-Mask's emotion. Channel feelings into actions. Don't just feel—do something. In other words, accept your feelings but do not indulge them. Instead, turn your attention toward becoming active.

Exercise 1.8: Dropping into Mask

twenty minutes per mask

You are now prepared for your first mask transformation—warmed up, senses alert, and emotions primed. Dropping into your first mask can be a moving experience. Be prepared to take what you get. Avoid pushing results in a particular direction. Allow your reflected image to instigate expressive physical shifts. If you lose connection with the Hu-Mask, look into the mirror and reconnect.

1. Sit quietly in neutral-ready with your first mask.
2. Take time to reconnect with the mask's triggers.
3. Move to the standing line, facing away from the mirror.
4. Look at your mask once again.
5. Put the mask on carefully.
6. Adjust head straps and hair.
7. Make simple physical shifts as you begin to drop into character.
8. Turn and face the mirror.
9. Continue to transform as you explore your image. Take your time.
10. Turn away from the mirror. Maintain your transformation.
11. Take off the mask and roll down to the floor.
12. Hunker down on the floor as you breathe, relax, and find neutral-ready.

13. Review this exercise in your mind's eye. Journal.

Discussion
- Were your physical shifts instinctive or planned?
- How did your physicality differ from your initial visual observation?
- Did you experience an immediate sense of transformation?
- Who did you become?
- What emotions, thoughts, and desires were present?

Take time to journal about mask one.

A note: Initial transformations may not perfectly match the character images that were triggered during mask observation. Usually, triggers remain unchanged but character traits are altered. If this is the case, go with your response when wearing the mask. This is what is happening in the moment. There's little point in fighting the actual transformation—it must take its course.

LET'S GET PHYSICAL

The body must be a centre of reactions. We must learn to respond to everything with our body, even to an everyday conversation.
—Jerzy Grotowski, Towards a Poor Theatre

The next three exercises focus on key elements of the mask's physicality: stance, walk, and gesture. It is critical in this (and all mask work) to avoid generalizations. Do not settle for vague notions of a Hu-Mask's physical demeanor. Rather, engage in serious investigation of each physical component. Rivet your attention to the placement of feet, hips, legs, arms, hands, fingers, and head. Note the precise manner in which internal and external rhythms are established.

Exercise 1.9: Stance
ten minutes per mask

Clarifying the physical nature of your mask begins with stance. Keep your stance fluid by breathing easily and avoiding the temptation to freeze. Do not lock your muscles when you are looking into the mirror. Experiment with a series of masks and stances. Base final decisions by trial and error. A precisely placed stance provides a physical foundation from which further explorations are launched.

1. Sit quietly in neutral-ready with your first mask.
2. Focus on those triggers you have already used.
3. Go to the standing line, put on the mask, adjust straps and hair.
4. Drop physically into the mask.
5. Turn and face the mirror. Check your stance.
6. Experiment with several different stances. Continue to modify.
7. Select one stance that embodies the Hu-Mask.
8. Adjust the stance as necessary.
9. Turn from the mirror and maintain the stance.
10. Take off mask, go to neutral-ready, roll down.
11. Review the work in your mind's eye. Journal.

Discussion
- How did the stance evolve?
- How accurate was it?
- Were you able to isolate specific body parts?
- In what ways does this mask differ from you?
- Are your stance discoveries repeatable?

Actors often describe early transformations and stance work in terms of purity—pure focus, thought, feeling, and action. Remember that each technique you acquire—including transformation, physical expression, focus, and emotional life—gives you the strength to act with confidence and commitment. Everything you experience in full-face masks is revisited and fortified in other sections with alternate

types of masks. Once you have transformed in a multiplicity of masks, articulation of stance and physical placement becomes second nature.

A note: You now know how to study your mask and drop in. In order to avoid redundancy, detailed instructions regarding these steps are minimized. This does not negate the importance of beginning the work properly. Avoid rushing through observation, triggering, and the standing line. Always complete the formative stages before attempting new steps.

Exercise 1.10: Walk

fifteen minutes per mask

Now that you have solidified stance (body relatively still), turn your attention to walk (body in motion). As you will see, the walk is developed in much the same way as the stance. You will have opportunities to *observe* your walk when looking into the mirror and then to *experience* it without looking in. Seeing your walk reflected allows you to fine-tune specific physical components—placement of feet, hands, arms, shoulders, and head. When you work without looking into the mirror, the walk is woven into the fabric of your body.

1. Drop into mask.
2. Revisit your stance.
3. Walk away from the mirror. Walk around the studio.
4. Maintain character as you walk toward the mirror and then walk away.
5. Move freely between walk and stance.
6. Go back to the mirror and reinvestigate the Hu-Mask.
7. Find your stance.
8. Drop out of mask, return to neutral-ready, and review work. Journal.

Discussion
- Describe how you refined the walk.

- How does walk relate to stance? What is the connective fabric?
- Is the experience of the walk stronger when looking into the mirror or looking away?

Exercise 1.11: Gesture
fifteen minutes per mask

Every Hu-Mask (indeed, every character) gestures in a distinctive manner. This may involve a flick of the hands, a nod of the head, a wink, a shuffle, or any combination of other physical mannerisms. It's valuable to find a primary gesture and rehearse it until perfected. Full-face masks provide a perfect opportunity to engage in gesture articulation. The gestures you find should be rooted in physical truth. When you find that truth, your gesture will be simple and direct. This gesture can be utilized during key moments of a performance. This technique is similar to Michael Chekhov's Psychological Gesture (although Chekhov suggested broader physical choices): "The Psychological Gesture stirs our will power, gives it a definite direction, awakens feelings, and gives us a condensed version of the character" (Michael Chekov, *To the Actor*).

Try not to preconceive your Hu-Mask's gesture. Once you are looking in, allow gestures to arise spontaneously. When a particular gesture doesn't work, scrap it and try a new one. Once you have isolated a powerful gesture, refine it through repetition. With adequate practice, you will "own" the gesture—just as you own the walk and stance.

1. Drop into mask.
2. Look into the mirror and find your stance.
3. Reestablish your walk, then return to the mirror and revisit your stance.
4. As you are standing, looking in at your reflection; gesture.
5. Repeat the gesture several times.
6. Now try a second gesture. Repeat gesture.
7. Move to a third gesture. Repeat gesture.

8. Choose the gesture that best suits this Hu-Mask. Repeat gesture several times.

9. Walk, stand, and gesture. Incorporate stance and gesture. Walk and gesture.

10. Drop out of mask, return to neutral-ready, and review work. Journal.

Discussion
- What led you to that specific gesture?
- How did you sharpen the gesture?
- Did the gesture sharpen the Hu-Mask?
- Describe the integration between walk and gesture. Stance and gesture.
- Which gestures did you discard? Why?

ESSENCE

Essence n. *The intrinsic nature or indispensable quality of something that determines its character.*
—The New Oxford American Dictionary, *2001*

Statues allow you to clarify the essence of your Hu-Mask. Statues should not be confused with stance. Stance is the way you stand. Statues are fluid moments of stillness that describe the unique inner and outer qualities of the Hu-Mask.

Clarifying essence fulfills several acting objectives. To begin, you fight against generalized choices. Refining the statue embues the Hu-Mask with precision. This clarifies psychological and emotional truth. Finally, revisiting statues is a tangible means of remembering who you are (in mask)—what you need and what you must do to fulfill that need.

Exercise 1.12: Statues
twenty minutes per mask

When developing new statues, work instinctively. Don't think. Trust your intuition. Allow time for refinement when you are looking into the mirror. Stay fluid and flexible—avoid freezing up. Flow from one statue to the next. Use repetition to refine physical articulation.

1. Drop into mask.
2. Physicalize before looking into the mirror.
3. Walk, stand, and gesture as before.
4. Return to the mirror.
5. Drop into Statue One. (Coach: say, "Statue One!" and clap your hands.)
6. Drop into Statue Two.
7. Drop into Statue Three.

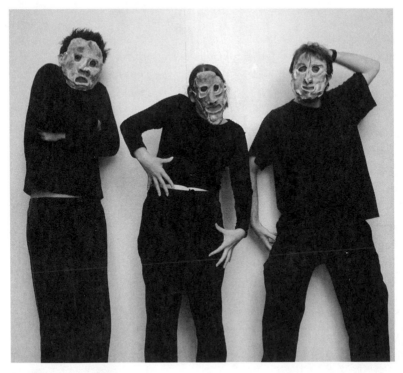

Hu-Mask essence statues

8. Statue One. Three. Two. One. Two. Three.
9. Now drop into Statue One. Add gesture.
10. Statue Two. Add gesture.
11. Statue Three. Add gesture.
12. Drop out of mask, return to neutral-ready, and review work. Journal.

Coach Advice
- Clap each time you call a number.
- Allow time for the actors to drop into each statue and gesture.
- Watch to see that physical adjustments are complete.
- Do not comment on the work.

SPEAKING UP

This is a good time to offer your Hu-Masks an opportunity to vocalize. Most full-face Hu-Masks do not vocalize unprompted; they need encouragement to find sounds. There are several reasons for this:

- The mask covers your mouth.
- You cannot see your lips moving.
- The mask mutes normal vibrations.
- Hu-Masks are childlike in nature and have not mastered language.

Without solid encouragement Hu-Masks remain silent or, at best, utter guttural sounds. When quiet masks begin to grunt, moan, sing, or speak, fascinating choices emerge. A new world of expression is unleashed.

Exercise 1.13: Finding Sounds
twenty minutes per mask
Most Hu-Masks do not speak your native language. You may wind up thinking and speaking a language you do not know. You may not be able to identify the language. Do not fight for logic. Do not expect

particular words or sounds. Be willing to create new phonetics and vocabularies. See what fits and stick with that. If your Hu-Mask still does not speak then it is a silent mask.

A note: Side coaching liberates mask vocalization. The coach prompts sounds by reminding actors to continue vocal exploration.

1. Drop into mask.
2. Find stance, walk, and gesture.
3. Look into the mirror and begin to statue.
4. Continue fluid statues as side coaching begins:
 - Okay Hu-Masks: try the sound AAAAAHHHHH
 - New statue.
 - Good, now try EEEEEEEEEEEEEEEE.
 - You can say AAAAAHHHHH or EEEEEEEE.
 - New statue.
 - Please try the sound OOOOOOOHHHHHHHH.
 - New statue.
 - Nice job, Hu-Masks. Feel free to make whatever sounds you like.
5. Walk around the space and vocalize.
6. Drop out of mask, return to neutral-ready, and review work. Journal.

Discussion
- What sounds worked? What sounds did not?
- Did you begin to develop a vocabulary? A language?
- Do you know how your Hu-Mask would communicate now, given the chance?

Try this exercise with two or three new masks. Introduce new sounds.

- If all of your Hu-Masks are silent, you're blocking vocal choices.
- If all of your Hu-Masks speak fluent English, you're opting for logic over truth.

WIGGING OUT

If you have ever played around with wigs (most actors have) you know that they are powerful transformers. Wigs trigger internal transformations in much the same way as masks. If you allow a Hu-Mask free choice, it will generally choose the same wig. When this occurs, the mask and wig meld—they just belong together. Interestingly, it becomes difficult, if not impossible, to continue masking without that specific wig.

Exercise 1.14: Wigs
ten-minute rotations, repeated in multiple masks
If you are not certain whether a particular wig will work, try it on for size. Trust your intuitive sense to retain or reject it. Hu-Masks will recognize good hairpieces instantaneously.

Set-up
Place wigs on a table near masks.

1. Drop into mask. Check stance, walk, and gesture.
2. Walk to wig table. Select a wig.
3. Put on the wig. Adjust as needed.
4. Look into mirror and practice stance, gestures, walk, and statues.
5. Continue to view yourself in the mirror as the character shifts.
6. Try new wigs, as needed. Return to mirror.
7. Walk away from the mirror and maintain wigged presence.
8. Drop out of mask and wig, return to neutral-ready, and journal.

Discussion
- What clued you into that wig?
- How did other wigs feel/look on your head?
- How did the wig affect your transformation?
- Did the Hu-Mask feel more complete?

CLOAKED IN MYSTERY

Cloaks have as much power to transform as wigs. Wrapping yourself in a cloak can deepen your character or change it completely. The flow and feel of fabric imbues your Hu-Mask with new meanings. Cloaks, like wigs, often become integral to masked explorations. In these instances, your Hu-Mask must be properly wigged and cloaked to proceed.

Exercise 1.15: Cloaks
Ten-minute rotations, repeated in multiple masks
Allow the cloak to deepen and alter your walk, gesture, and stance. Feel free to alter the drape of the cloak until it fits your Hu-Mask's inclinations. There are innumerable ways to incorporate this element:

- Sling it over your shoulders.
- Wrap it around your waist.
- Pull it over your head.
- Create a skirt.
- Stuff it into your shirt or pants.
- Tie it around your legs.

1. Place cloak on chair near the mirror.
2. Drop into mask. Put on your wig. Check stance, walk, and gesture.
3. Wrap yourself in the cloak. Adjust as needed.
4. Look into mirror and practice stance, walk, gesture, and statues.
5. Continue to adjust cloak until it is right.
6. Walk away from mirror and maintain Hu-Mask.
7. Drop out of cloak, wig, and mask, return to neutral-ready, and journal.

Discussion
- Did your Hu-Mask accept or reject the cloak?
- How did it affect your physical and psychological bearing?

- How did mask, wig, and cloak interface?
- Did you yearn for other articles of clothing to flesh out the costume?

Progression of transformation

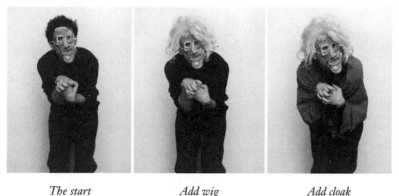

| *The start* | *Add wig* | *Add cloak* |

CHILD'S PLAY

A new mask is like a baby that knows nothing about the world. Everything looks astounding to it, and it has little access to its wearer's skills.
 —*Keith Johnstone,* Impro

Full-face Hu-Masks are childlike in nature. This does not necessarily refer to their age (although some are youngsters) but their mind-set. Your Hu-Mask may be as old as the hills but, generally speaking, mental activity remains juvenile. Simplicity is the name of the game. Language, as you have now discovered, is primitive at best. Hu-Masks' thoughts are generally slower than yours. They find fascination in simple objects. Most rotations are invitations to return to childhood. Therefore, focus on accomplishing one task at a time.

Exercise 1.16: Simple Doing
twenty-five minutes in same mask

This exercise enables you to experience sustained transformation while engaging in a simple activity. Take your latest Hu-Mask—wigged and cloaked—and introduce simple tasks. Activities may be assigned prior to dropping in, or discovered in mask. It's interesting to work both ways:

- *Prescribed* activities force you to become active in new ways.
- Selecting tasks *after* transformation clarifies the inclinations of the Hu-Mask.

Set-up
A table with simple props and other assorted knick-knacks.

Suggested tasks
- Coiling a rope—a long piece of string will do
- Planting seeds—a trowel is handy
- Reading a book—foreign languages work well
- Stirring a pot—a stick or large spoon
- Stacking blocks—simple wooden variety
- Drawing with crayons—one or two crayons and a piece of paper
- Playing cards—invent simple games

Do not predetermine the activity. See what the Hu-Mask is interested in doing. Take the time you need to explore each activity. The nature of your character will come into focus as you concentrate on that simple task. Always concentrate on the task at hand. Allow the Hu-Masks to complete activities *their* way. Don't try to demonstrate how *you* would do it. Feel free to sing or vocalize as you work.

1. Sit with your mask in neutral-ready.
2. Take time to study your mask, drop in, and find walk, stance, and gesture.
3. Add wig and cloak as needed.
4. Walk to the prop table.
5. Choose a prop and begin to explore an activity.

6. Continue to explore activity. Then walk to the mirror.
7. Practice three statues with activity gestures.
8. Drop out of mask, return to neutral-ready, and journal.

Discussion
- What did you learn about this Hu-Mask?
- Which tasks were tailor-made for the Hu-Mask? Which were struggles to complete?
- Did you get a sense of your Hu-Mask's occupation (present or former)?
- How attentive were you during the activity?
- Did you attach meaning to the activity?

A note: You may find yourself wanting to play with other Hu-Masks. Resist this temptation during beginning and intermediary exercises. Premature interaction will throw you and your peers off course. Concentrate instead on transformation and simple activities—this will more than occupy your Hu-Mask's mind, body, and spirit for now. There will be ample opportunities to engage in group play during subsequent exercises.

CORE EXERCISES: IN AND OUT OF FULL-FACE MASKS

It is entirely feasible to create masked characters and use those choices for non-masked roles. Activities provide opportunities to explore these options. The following two exercises shift between masked and unmasked activities.

Exercise 1.17: In and Out of Mask
fifteen minutes in same mask
This allows you to experience working in and out of masks. You will utilize masked choices for non-masked activities. Trust the clarity of your physical and vocal Hu-Mask choices. Maintain those choices when unmasked. Focus intently on your activity.

1. Return to the same mask, wig, and cloak used in exercise 1.16.
2. Reconnect with this Hu-Mask.
3. Begin the same activity.
4. Practice the activity for several minutes.
5. Take off the mask and continue for several minutes with the same activity.
6. Maintain Hu-Mask choices throughout.
7. Return to neutral-ready and journal.

Discussion
- Were you able to reconnect with the Hu-Mask and activity?
- What occurred when you removed the mask?
- Were you able to sustain transformation out of mask?

Exercise 1.18: Putting Baby to Sleep
fifteen minutes in new mask
This deepens intention through activity. Your Hu-Mask follows a predetermined activity: putting your baby to sleep. Engage your voice and body as you fulfill the primary goal. You may find yourself singing. If so, notice how your voice fluctuates in order to soothe the infant.

Set-up
Place a wrapped blanket near the mirror.

1. Drop into mask, wig, and cloak.
2. Reconnect with walk, stance, gesture, and multiple statues.
3. Find your voice.
4. Pick up baby near the mirror.
5. Put your baby to sleep (sing, if possible).
6. Take the mask off and continue task.
7. Maintain Hu-Mask choices throughout.
8. Return to neutral-ready and journal.

Putting baby to sleep: masked *Putting baby to sleep: out of mask*

Discussion

- Were you able to achieve your objective?
- Were you able to sustain Hu-Mask choices out of mask?
- How did your voice help you to calm the baby?
- In what ways did your voice and body work together?

CORE EXERCISES: REVIEWING AND MODIFYING

Returning to a mask fortifies your ability to recreate Hu-Masks with accuracy. You will discover new ways of moving and communicating that further define the principle traits of that mask. This is a good time to review Modifying Results—exercises 1.5 and 1.6.

Exercise 1.19: Maximizing Hu-Mask Discoveries
fifteen minutes in familiar mask
Choose a favorite mask that triggered a noteworthy transformation. Take time to reconnect with that Hu-Mask. Next, maximize

each aspect of the character. Maximizing discoveries promotes highly articulated acting.

1. Revisit Hu-Mask.
2. Explore the statue. Maximize statue to levels 6, 8, and 10.
3. Explore the walk. Maximize the walk to levels 6, 8, and 10.
4. Explore gestures. Maximize gestures to levels 6, 8, and 10.
5. Explore voice. Maximize voice to levels 6, 8, and 10.
6. Reconnect with activities. Maximize activities to levels 6, 8, and 10.
7. Return to mirror and integrate maximized qualities.
8. Drop out of Hu-Mask and return to neutral-ready.

Discussion
- What aspects of the Hu-Mask did you most successfully maximize?
- What aspects were more difficult to maximize?
- Did maximized levels further articulate the nature of the Hu-Mask?

Exercise 1.20: Minimizing Hu-Mask Discoveries
fifteen minutes in familiar mask

1. Repeat exercise 1.19 but rather than deepen discoveries, tuck them away.
2. Move through levels 5, 3, and 1.

Now repeat exercises 1.19 and 1.20 with new masks. Continue your masked explorations until you are satisfied that the work is complete. When you have reached an acceptable level of energy and placement, move to another mask. Exposure to multiple masks expands your ability to shift, transform, and create spontaneously.

This completes primary full-face mask exercises. Time permitting, review exercises 1.8 through 1.19 with several new masks. Combine exercises as your ability to mask increases. For example, drop

into your second mask, locate stance, and walk during a single rotation. Then, combine gestures and statues. Add a wig and cloak during one rotation. Discover new sets of walks, stances, gestures, wigs, cloaks, statues, and activities. Remove your mask and maintain choices un-masked. Take time to discuss discoveries. Maintain an up-to-date journal—this ensures accurate mask revisitations.

ADVANCED EXERCISES: GROUP MASKING

You have now acquired core full-face masking techniques: finding triggers, transforming physically, vocally, and emotionally, engaging in activities, working in and out of masks, and modifying results. Advanced techniques are based on interactive explorations. Most Hu-Masks are eager to play with other Hu-Masks. A few prefer to live in the corners of the studio, protecting their solitude. These reclusive Hu-Masks will need a bit of encouragement to emerge from their shells. It is well worth the effort; Hu-Masks flourish in groups. Simple games promote playfulness, spontaneity, and ingenuity.

Exercise 1.21: Singing Together
ten minute rotations, repeated in multiple masks
Combine new masks and old. Follow your impulses. Do not predetermine how the Hu-Masks will sing.

A note: Limit the number of actors in each masking rotation to eight. Excessively large groups can become unmanageable.

1. Actors drop into masks.
2. Reconnect with walk and voice.
3. Add wig and cloak as appropriate.
4. Hu-Masks create a circle.
5. One Hu-Mask (not predetermined) begins to sing.
6. Other Hu-Masks join in.
7. Remove mask and continue singing.

8. Replace mask, complete the song together, and return to mirror.
9. Statue with singing.
10. Drop out of mask, return to neutral-ready, and journal.

Discussion
- What sounds surprised you?
- Were you able to maintain character in and out of mask?
- How was the group song forged?
- What types of relationships were established within this rotation?

Exercise 1.22: Dancing Together
ten-minute rotations, repeated in multiple masks
Allow partners to influence your dance moves. Maintain choices in and out of masks.

Experiment with diverse types of music:

- Hip-hop
- Country Western
- New age
- Blues
- Classical
- Klezmer
- Jazz
- Woodwind ensemble

1. Drop into mask and focus on physicality.
2. Coach plays music.
3. Hu-Masks dance singly.
4. Hu-Masks dance in pairs.
5. Hu-Masks dance as a group.
6. Take off mask and continue to dance.
7. Return to mirror and practice dance moves.
8. Put on mask. Statue dance moves.

9. Drop out of mask, return to neutral-ready, and journal.

Discussion
- Did you maintain physical truth as you danced?
- Was physical essence heightened?
- Describe discovered relationships.

Exercise 1.23: Going Outside
fifteen minutes in same mask

Changing environments profoundly affects the way masks perceive themselves, others, and the world around them. Do not run off. Stay away from streets and cars. Avoid conversations with non-masked people.

1. Drop into mask.
2. Find walk, stance, and gestures.
3. Add wig and cloak, as needed.
4. Practice statues in mirror.
5. Walk away from the mirror. Return. Walk away.
6. Entire group goes outside for a walk.
7. Allow Hu-Masks to explore the environment (ten minutes).
8. Return to studio.
9. Statue with gestures in mirror.
10. Drop out of mask, return to neutral-ready, and journal.

Watchers
It's important to closely monitor the Hu-Masks. They tend to wander off and might disappear altogether (and, in transformed states, actors tend to lose track of time). Usually, non-masked people watch the Hu-Masks from a safe distance or else hurry off in the other direction. Discourage non-masked watchers from interacting with the actors (interaction will be fostered in half-face masks).

Discussion
- How did the change in environment affect you?

- What surprises did you encounter?
- Did you notice non-masked people? How were they perceived?

Exercise 1.24: Play Ball!

twenty minutes in familiar or new mask

This is a fresh-air game. The rules of the game are developed spontaneously. Actors work in and out of masks. Allow the Hu-Masks free reign to develop the game. Continue with your mask from exercise 1.23 or select a new mask.

1. Follow the initial format of exercise 1.21. After the Hu-Masks are outside:
2. Coach throws the Hu-Masks a ball.
3. Hu-Masks play ball. Include all Hu-Masks in the game.
4. Rules of the game develop spontaneously.
5. Remove mask and continue to play ball in character.
6. Put on mask and continue to play.
7. Return to the studio in mask.
8. Statue in mirror in mask.
9. Statue in mirror out of mask.
10. Statue in mirror in mask.
11. Drop out of mask, return to neutral-ready, and journal.

Discussion
- How did you feel about playing ball?
- How did the rules evolve?
- Were you able to sustain character out of mask?

Exercise 1.25: Faraway Village Adventure

forty minutes in same mask

This incorporates group effort, imaginative play, a complex scenario, and sustained transformation. Active side-coaching helps keep the Hu-Masks on track. Review given circumstances and story line before dropping into mask. Everyone must be on the same page.

Each actor develops a Faraway character. The Faraway village language is developed improvisationally and collaboratively, as the scene evolves. Words arise from action and need. English is not permitted.

Sustain individual character traits throughout the exercise. Listen and react to your fellow villagers. Do not attempt to control the flow of action. Allow your sense of belief to deepen throughout the activities. Stay in the moment, deeply connected to immediate objectives.

1. Drop into mask, wig, and cloak.
2. Find stance, walk, and gesture.
3. Practice five different statues in the mirror.

Script—cued by coach (allow time for Hu-Masks to complete each instruction)

4. Hu-Masks: Sleep together in a group on the floor.
5. Awaken and gather wood for a fire.
6. Build a fire and prepare breakfast.
7. Sing a song and eat breakfast together.
8. Suddenly, someone realizes that a prize dog is missing.
9. Everyone looks for the dog but it cannot be found.
10. The group comes together to launch a dog-finding mission by sled.
11. Hu-Masks: Hop on the sled and search for the dog.
12. The dog is finally found, put on the sled, and brought back to camp.
13. Dance, sing a new song, and celebrate.
14. The group feeds the dogs and puts them to bed.
15. Stoke the fire.
16. Dance.
17. Eat supper.
18. Hu-Masks go to sleep in a clump on the floor.
19. Drop out of mask, return to neutral-ready, and journal.

Discussion
- Was the group able to work together?
- How did the language evolve?
- Were you able to sustain transformation throughout this prolonged exercise?
- Did you sense environmental elements such as snow, cold, wind, etc.?
- Revelations?
- Who were the leaders? Followers? Describe the social structure of the group.

Exercise 1.26: Marketplace
twenty minutes in a new mask

This explores complex transactions within a group. The setting is a small non-American village. Everyone has something to sell. Everyone has something to buy. Haggling over prices is expected. Your language, based on individual Hu-Mask traits, evolves along with the scene. Maintain the integrity of your Hu-Mask objectives whether in mask or out. Invest objects with meaning. You must believe that you have something valuable to sell. You must also have a strong desire to buy. Listen intently to other Hu-Masks; you cannot consummate transactions by yourself. Interactions demand keen collaboration.

Set-up

Place varied props on a table. These are bought and sold.

Divide actors into two groups: Group I and Group II.

1. Drop into mask.
2. Add wig and cloak.
3. Find walk, stance, voice, and gesture.
4. Practice five statues in the mirror.

Script—cued by coach (allow time for Hu-Masks to complete instructions)

5. All Hu-Masks go to prop table and find a prop.

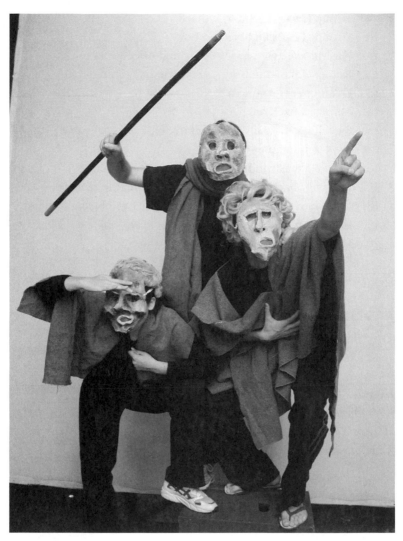

Looking for the dog

6. Hu-Masks sit or stand alone and either build, repair, or clean objects to sell.
7. Group I walks to marketplace with objects.
8. Group I sets up shop and begins selling objects.

9. Group II walks to marketplace.
10. Group II finds an object to buy.
11. Hu-Masks haggle over quality and price (ten minutes).
12. Remove mask and stay in character (ten minutes).
13. Deals are consummated.
14. Put mask back on.
15. Switch positions in marketplace: Group II sells and Group I buys (ten minutes).
16. Remove mask and stay in character (ten minutes).
17. Put mask back on and return home from the market.
18. Look into the mirror and statue with your object.
19. Remove mask and continue to statue with object.
20. Return to neutral-ready, rest, and journal.

Discussion
- Were you able to maintain your mask transformation?
- Talk about the objects that you coveted.
- How did the language evolve?
- Was it possible to understand everything that was said and done?

Exercise 1.27: Wilderness Adventure
forty minutes in a new mask
Here is a madcap story to enact. The central challenge is to sustain transformation from beginning to end.

1. Drop into mask. Add wig and cloak as needed.
2. Find stance, walk, and gesture.
3. Practice five statues in mirror.

Script—cued by coach (allow Hu-Masks time to complete each instruction)
4. Hu-Masks: Get into your sailboat or rowboat.
5. Take the boat out into the river.
6. Drift and fish.
7. A storm is brewing. It starts to rain. The wind picks up.

8. Now you are zipping down whitewater in the storm.
9. You go down a waterfall.
10. At the bottom of the waterfall, you are tossed out of the boat.
11. Climb back into your boat and row to shore.
12. Tie up your boat at the shoreline. Get dry.
13. Now you are at the edge of a forest. Walk into the forest.
14. You find other Hu-Masks in a forest clearing. You are long-lost friends.
15. Everyone dances together in the forest.
16. Remove masks and dance. Put masks on and dance.
17. The weather clears up. Return to your boat and sail or row home.
18. Drop out of mask, return to neutral-ready, and journal.

Discussion
- What triggered your transformation?
- Did you remain fully transformed throughout the journey?
- Could you see, feel, taste, and hear the river, waterfall, storm, and forest?
- Discuss details and discoveries.
- Describe being storm-tossed and saved.
- Were you able to sustain character essence in and out of mask?

APPLIED FULL-FACE MASKING

THE GREEKS

When you produce the greatest effect upon the audience are you in your right mind? Are you not carried outside of yourself?

—Socrates

Ancient Greek theater enjoyed a golden age of playwrighting and production between 530 and 400 B.C. During this period, the seminal

playwrights of the age—Aeschylus, Sophocles, and Euripides—addressed the fundamental nature of mankind and its relationship to the gods, society, laws, traditions, and fellow humans. Their plays contained the seeds of modern Western theater. They solidified theatrical traditions, reinforcing seminal practices such as the inclusion of protagonists (heroes) and antagonists (villains), the cohesion of story lines (with strong beginnings, middles, and endings), cathartic moments (life-altering realizations), choral odes, individualized characters, strong actions, and cohesive plots. Their plays—including the *Oresteia, Antigone, Oedipus Rex, Electra, Medea, The Bacchae,* and *The Trojan Women*—conveyed important societal messages: the inherent strengths and weaknesses of rulers, mankind's place in the universe, and the power of the gods to reward or destroy civilization. Performances were rendered in large outdoor amphitheatres. The community came to the theater to witness and debate the merits of these wondrous plays and the issues they addressed.

Actors were called upon to portray a wide range of characters: gods, kings, servants, muses, and prophets. Iconic figures, difficult for any mortal thespian to embody, were sustained through the inherent power of full-face masks. Indeed, these masks were designed to project the actors' voices to the back rows of the theater. You can imagine the empowering effect of magnified features, broad gestures, and projected voices. We might find this acting style laughable, given our current penchant for realism, but those choices served a purpose: The actors were able to embody supernatural characters confronted with life-or-death situations.

There are myriad wonderful Greek plays that merit exploration in and out of full-face masks. For our purposes we will focus on *The Trojan Women,* by Euripides. This is a high-stakes drama that offers splendid acting challenges for high- and low-status men and women. The action is set in war-ravaged Troy, after the siege of Greek forces has reduced it to smoldering rubble. You have already inhabited full-face Hu-Masks that can play the selected roles.

Keep in mind that the following exercises are predicated on accurately delivered lines. It is imperative that you select vocal Hu-

Masks. Do not embark on these exercises with a silent mask; there is nothing to be gained by unwarranted frustration. In the interest of solid preparation, read *The Trojan Women* carefully from beginning to end. Memorize the monologues word for word. This facilitates precisely spoken lines.

A note: This translation is by Richmond Lattimore. Feel free to use other translations, provided they are not overly romantic. Lattimore's translation strikes a good balance between poetry and verbal accessibility. The language is well-suited for Hu-Mask experimentation.

Exercise 1.28: Servant

twenty minutes with familiar speaking mask

Troy is smoldering at the hands of the avenging Greeks. The men have been killed and the women are enslaved. We begin with a servant's monologue, as delivered by Talthybius. This part was originally written for a male servant but can be played by a female. What is his/her missive? To make sure that the spoils of war are distributed according to company orders. Talthybius cannot put pride before common sense. There are nasty details to attend to: The women of Troy have been sold into bondage and must be distributed to their new Greek masters. Select a simple, speaking Hu-Mask that is docile and efficient. Talthybius can be wise or dim-witted, depending on the nature of your Hu-Mask. Physical and vocal attributes will, by necessity, vary from mask to mask.

Male or female

> Talthybius: Men-at-arms, do your duty. Bring Kassandra forth
> without delay. Our orders are to deliver her
> to the general at once. And afterwards we can bring
> to the rest of the princes their allotted captive women.
> But see! What is that burst of a torch flame inside?
> What can it mean? Are the Trojan women setting fire
> to their chambers, at point of being torn from their land
> to sail for Argos?

Be sure to allow your Hu-Mask time to see the flame (a torch carried by Kassandra) bursting forth. This marks a significant shift in the speech. Keep your work simple and pointed. Do not overact. Take care of business.

1. Drop into mask, wig, and cloak.
2. Looking into the mirror, rediscover physical and vocal attributes of mask.
3. Rediscover Hu-Mask, away from the mirror.
4. Drop out of mask, return to neutral-ready, and lie on your back.
5. Recite monologue several times in neutral-ready.
6. Drop back into mask and reestablish Hu-Mask.
7. Recite monologue as Hu-Mask.
8. Repeat monologue several times.
9. Drop out of mask, return to neutral-ready, and journal.

Discussion
- Was this Hu-Mask able to recite the lines?
- How did the monologue affect transformation?
- How did the Hu-Mask's acting differ from yours?

Exercise 1.29: Royalty
thirty minutes with familiar speaking mask
Choose powerful, emotional, vocal Hu-Masks. Actors need not remain gender bound—men can play Hecuba, women can play Menelaos. Base your decision on the gender of your Hu-Mask. Remember that Hecuba is older and Menelaos is middle aged. As always, be specific when incorporating your Hu-Mask's physical, vocal, and emotional attributes.

Follow the steps outlined in exercise 1.28.

Female
Hecuba: Oh no, no!
 Tear the shorn head,
 rip nails through the folded cheeks.

Must I?
To be given as slave to serve that vile, that slippery man,
Right's enemy, brute murderous beast,
that mouth of lies and treachery, that makes void
faith in things promised
and that which was beloved turns to hate. Oh, mourn,
daughters of Ilion, weep as one for me.
I am gone, doomed, undone,
O wretched, given
the worst lot of all.

Hecuba, the aged queen of fallen Troy (Ilion), has been told her terrible fortune: to be enslaved to Oedipus, captor of her people and a victor over Troy. Do not give in to inherent sorrow. Find Hecuba's spirit to fight. She is still, and will ever be, a queen—composed of pride, strength, and power. Taste each word. Allow your Hu-Mask to experience individualized moments of realization. Match your movements with Hecuba's dissolving fate.

Male

Menelaos: O splendor of sunburst breaking forth this day, whereon
I lay my hands once more on Helen, my life. And yet
it is not, so much as men think for the woman's sake
I came to Troy, but against that guest proved treacherous,
who pirate-like carried the woman from my house.
Since the gods have seen to it that he paid the penalty,
fallen before the Hellenic spear, his kingdom wrecked,
I come for her now, the wife once my own, whose name
I can no longer speak with any happiness,
to take her away.

Menelaos is a general in the Greek (Hellenic) forces that have conquered Troy. Helen, Menelaos' beautiful wife, was seduced by Paris (a rival soldier) and taken to Troy. This incident catalyzed the Greeks'

thirst for revenge and war. Now Paris is dead and Troy lies in ruins. At this moment in the play, Menelaos enters to reclaim his wife. Allow your Hu-Mask to relish each change in emotion: from splendor to treachery to revenge to bitterness. Speak clearly and decisively. Match your Hu-Mask's physicality with the inherent power of this troubled leader.

Exercise 1.30: Review—Working In and Out of Mask

It is important to know that you can use masked discoveries to inform non-masked assignments and that results are modifiable. For example, you might be asked to perform one of these speeches in mask or out of mask. Your performance venue might be a large outdoor theatre or a small studio space. Flexibility is the key.

1. Re-establish the Hu-Mask you used for one of the Greek speeches.
2. Recite the speech in mask.
3. Remove the mask and maintain transformation.
4. Recite the speech again, out of mask.
5. Continue working as you maximize physical choices. Use levels 6, 8, and 10.
6. Maximize vocal choices. Use levels, 6, 8, and 10.
7. Now minimize physical choices. Use levels 5, 3, and 1.
8. Minimize vocal choices. Use levels 5, 3, and 1.
9. Find the level that best suits this character.

Discussion
- Were you able to use your Hu-Mask discoveries out of mask?
- Were you able to modify your acting?
- What physical and vocal levels would you choose for performance?

IN CONCLUSION

The art of masking is experiential—you learn by doing. In the interest of augmenting your burgeoning skills, dedicate time and energy

to further masked investigations. It is always beneficial to integrate familiar Hu-Masks with ones that are new. As you have seen, there are myriad ways to utilize full-face masks in masked or non-masked endeavors. Triggering, transforming, engaging in activities, pursuing objectives, playing with other Hu-Masks, tackling scripts, sustaining extreme characters, and working in and out of masks are achievable through practice. The more you remove your logical mind from the process, the further your instincts will carry you. If you become restless, take a break. Move to another set of masks. Return to full-face masks when you desire a deeply transformative experience, when your own skin and bones are not enough, or when you need to replenish your creative forces by inhabiting someone else.

BAG MASKS

OVERVIEW

This section presents multifaceted artistic challenges: script writing, mask building, and multiple character performance. You are at the epicenter of this process and, as sole creator, sustain each component of the work. Therefore, the quality of your bag performances rests, along with the bag itself, firmly on your shoulders.

In every facet of acting, sloppy execution begets sloppy results. High-level bagging is predicated on clearly delineated moments. These masking techniques incorporate laser-sharp focus and wholehearted commitment to each moment of being and doing. You must strive to clarify every micro-second on stage. When you achieve this level of heightened precision, your acting skills soar.

Bagging exercises offer opportunities to incorporate techniques discovered in other families of masks. These include deep transformation—acquired in full-face masks, and instant transformation—acquired in half-face masks. Keep those techniques in mind as you launch explorations in bag masks.

TERMINOLOGY

1. A *bag mask* is the object that rests on your shoulders and covers your face.

2. A *Hu-Bag* is the character you become with one surface of the bag facing forward.
3. *Dropping in* refers to the moment you put on the bag mask and begin the process of transformation.
4. *Dropping out* refers to the moment you take off the bag mask and return to your self.
5. *Neutral-ready* is your state of alert relaxation prior to dropping in and after dropping out of bag mask.
6. A *neutral walk* is your means of entering or exiting in a relaxed ready state, without commenting on the merits of the performance.
7. *Shifting* denotes a change in your acting. These are physical, vocal, psychological, or emotional in nature.

SHIFTY BUSINESS

Shift v. *Change in emphasis, direction, or focus.*
Change gear in a vehicle: she shifted down to fourth.
—The New Oxford American Dictionary, *2001*

Bag masking begins with one-character monologues and progresses to two-, three-, and four-character scenes in which you play all the parts. The work escalates in difficulty, character by character, exercise by exercise. Your success in multiple-character performances is predicated on precise handling of acting shifts.

Acting shifts encompass a wide range of human behavior. A shift can be physical, vocal, emotional, or psychological in nature. Every shift, whether big or small, influences the tempo and direction of a scene. Brilliant actors are capable of shifting from screams to whispers, rapid movement to stillness, giggles to tears, and vulnerability to sheer power. These shifts define the boundaries of an actor's range. Actors that shift fluidly, cleanly, and dramatically do not fall prey to boring choices. Their work is a kaleidoscope of intriguing moments.

Shifting cleanly is integral to a strong acting process. Muddy shifts indicate a befuddled actor. Clean shifts imply clarity of thought

and action. Bag masking provides a framework for testing and improving highly articulated shifts. With diligent practice, bagging hones your ability to shift with power and precision.

PRE-BAGGING

MAKING BAG MASKS

Constructing bag masks is a low-tech endeavor. Do not worry about creating the next Mona Lisa—this is not a best-in-bag competition. Even those with little or no mask building experience can create wonderfully expressive bags. Fulfilling your design concept is gratifying, as is inhabiting the bag once it is built. After all, you are the sole creator of the mask and sole inhabitor of consequent Hu-Bag characters. The bag and Hu-Bags are yours—in imagination and reality. You have earned the privilege of bringing each original character to life. *Please see appendix for bag mask building instructions.*

Various types of bags

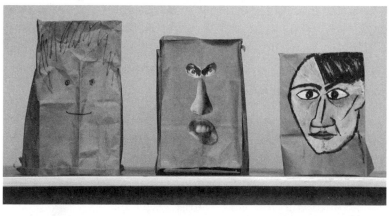

| *Simple* | *Semi-complex* | *Complex* |

STUDIO SET-UP

Arrange the audience on one side of the room in a series of straight, compact rows (no semicircles). Watchers should look straight forward at the front surface of the bag mask. If you are seeing the side surface (a different Hu-Bag face) the performance is skewed.

Place a single flat off stage. Actors begin behind the flat, neutral walk to center of the playing area, orient to the audience, put on the bag, and begin.

NEUTRAL WALK

Bag mask exercises are framed by a neutral walk entrance and exit. In the neutral walk, you move from point A to point B with just the amount of energy required to traverse the studio. This does not imply low-energy slouching or shuffling. Your neutral walk should have physical integrity without excess tension.

A well-executed neutral walk allows you to enter the performance space without commenting on your work. The audience perceives you walking into the space, going about your business, ready to perform—nothing more, nothing less. At the moment you put on the bag, both you and the audience focus on the significance of the initial transformation. Your performance proceeds from there.

When you have finished performing, take off the bag and look at your audience. Do not stare. Do not laugh or grimace. Relax your face. Remain neutral about your creative efforts. Maintain neutrality during your exit walk. Framed by neutral walks, your performance stands on its own merits.

Exercise 2.1: Neutral Walk
fifteen minutes—rehearsal

1. Stand with your feet at shoulders' distance.
2. Relax your arms, legs, hands, feet, and butt.
3. Allow your head to float easily atop your aligned spine.

4. Breathe deeply and relax your face.
5. Walk from one side of the studio to another.
6. Check for unnecessary physical tension.
7. Breathe to tension spots and release.
8. Roll easily through your feet as you continue to breathe easily.
9. Stand, and then scan your body and face relaxed.
10. Repeat the neutral walk several times.

CORE EXERCISES: ONE-CHARACTER BAGGING

> *The creation of something new is not accomplished by the intellect but by the play instinct, acting from inner necessity. The creative mind plays with the objects it loves.*
>
> —*C. G. Jung*

MASK PERFORMANCES—IT'S IN THE BAG

The first set of exercises permits you to experience the art of bag masking with just one character. Concentrate on working for specificity and truth. Do not allow your monologues to become larger than life. You may *feel* larger than life but, for the time being, do not become a bag god. As always, strive for physical and vocal truth. Keep your scripts succinct. Pay special attention to stance, head position, and gestures—these are accentuated in bag masks and breathe life into each Hu-Bag creation.

You must face straight downstage. But beware: Working without eyeholes can be disorienting. Many actors wind up turning in the wrong direction. The surfaces of bag masks are flat, so that even a slight rotation to your right or left means only half the audience can see the Hu-Bag face. This is especially problematic during advanced exercises when additional faces adorn the sides of the bag (it may appear as though the wrong Hu-Bag is speaking). Therefore, when

you are rehearsing, plant your feet firmly on the floor and look out to the center of your imaginary audience. Orient yourself accordingly during studio performances.

Exercise 2.2: A Friend
one minute performance
Find a common grocery bag that fits easily over your head. Create the face of a friend on one side of your bag. Prepare a one-minute monologue for this friend.

1. Enter from offstage.
2. Neutral walk to performance area carrying the bag.
3. Put on the bag and drop instantaneously into Hu-Bag friend.
4. Perform the monologue.
5. Take off the bag mask and return to neutral.
6. Neutral walk exit, carrying the bag.

Discussion
- Did the neutral walks frame the monologue? Was the actor commenting on the work during entrance or exit?
- How thorough was the initial shift into Hu-Bag character?
- Was the performance believable?
- Were physical and vocal clarity sustained from beginning to end?

These are fundamental discussion questions. Use them during repeat performances.

IMPROVING: DEEPER AND CLEANER

It's a sound practice to repeat bag mask exercises. This provides opportunities to incorporate ideas generated in post-performance discussions. Repetition solidifies physical bearing, vocal placement, focus, and shifts.

One-character bag

A note: Entrance and exit steps, including neutral walk directions, are not repeated for the remainder of this chapter. Please follow the steps delineated in exercise 2.2.

Exercise 2.3: Once More, with Clarity
one-minute performance

This is an improvement rotation. As such, make minor alterations to the script. Deepen your physical and vocal choices. Fortify the character's need to speak. Increase your acting focus from beginning to end.

1. Repeat the monologue from exercise two.
2. Deepen the intent of each line.
3. Increase the Hu-Bag's physical and vocal articulation.

Discussion
- In what specific ways did the performance improve?
- Discuss character traits that were most convincing.

SURPRISE, SURPRISE

Adding surprises enriches acting moments and breathes life into Hu-Bag characters. Even minor surprises can result in dramatic changes. Each alteration reminds us that original scripts and performances can always be improved. The truth is, your options are limitless.

Exercise 2.4A: Surprise I
one-and-a-half-minute performance
Add a verbal surprise to your single-face bag mask performance.

Exercise 2.4B: Surprise II
one-and-a-half-minute performance
Add a physical surprise to your single-face bag mask performance.

Discussion
- Was the actor genuinely surprised?
- Was the audience genuinely surprised?
- How did each new moment alter the performance?
- What surprises might you add now?

Remember that deepening choices and adding surprises can be achieved in these and all acting performances. Make a point of doing just that as you continue working in bag masks. For example, during repeat rotations, add one or two unexpected moments.

Adding a surprise

CORE EXERCISES: TWO CHARACTER BAGGING

VOCAL SHIFTS

You are now ready for an additional challenge: creating and performing decisive shifts in two-character bag masks. These scenes are more than twice as difficult as single-character bags. Both characters must be differentiated in body, voice, thought, tempo, and emotion. But attempting to shift all of these components at once is daunting.

It is best to shift in layers—incorporating one new element at a time. We begin with vocal shifts.

Remember that shifting, and shifting well, strikes at the heart of scintillating performances. Top-flight actors know how to shift on a dime. Their ability to do so leaves them open to surprises, discoveries, and adjustments. Once you are capable of shifting cleanly between several characters, you have strengthened your ability to execute meaningful shifts within a single role. Multiple-character shifting also strengthens your ability to handle multiple-role casting (in a single play where you play several characters).

Bag Construction and Staging

Render one face on the front surface of the bag, the other on the back. Leave the side surfaces blank.

Avoid staging a typical theatrical conversation in which the protagonist angles to the left and the antagonist to the right. Stand facing straight forward for *both* characters. The turn of the bag signals the moment of character shifting. Diligently practice turning the bag as you shift from one Hu-Bag to the next. Sloppy bag turning is ruinous. Clean turns imbue your choices with exactitude.

Exercise 2.5: Simple Conversation
two-minute performance

Write and memorize a two-minute sit-down conversation featuring two family members. Incorporate six to eight lines per character. Make sure you grasp why both characters are in the scene and what they want. Using familiar people allows you to tap accurate vocal traits; you have heard these voices throughout your life. Spend fifteen minutes per Hu-Bag character specifying that relative's vocal pattern. If you cannot pinpoint vocal traits, make a phone call and record the conversation.

Invest time practicing the bag turns. Each turn initiates a character switch. As always, each shift must be precise.

Sample scene

 Sis: Where are the keys?

 Dad: How should I know? Did you lose them?

 Sis: Help me. I need to go out.

 Dad: You are always losing things.

 Sis: I am not. I do not lose things.

 Dad: Then where are the keys?

 Sis: That's what *I'd* like to know.

 Dad: You cannot be trusted, Sis.

 Sis: That is so unfair.

 Dad: I will not give you the keys. You are bad.

 Sis: Please Dad. Please? I love you. Keys?

This is a good bag scene for several reasons:

- There are simple needs at play. Sis needs the keys. Dad steadfastly holds his ground.
- Dad is Sis's obstacle. Sis must shift through several tactics to obtain her objective.
- Dad must shift to deny the keys to Sis.
- The lines are short and easy to remember.

1. Neutral walk to performance area, carrying the bag.
2. Put on the bag and drop immediately into the first family member. Speak.
3. Shift to the second family member. Reply with vocal shift.
4. Complete the scene, take off the mask, and return to neutral.
5. Neutral walk exit.

Discussion

- Were the characters differentiated?
- Were the shifts between characters clean?
- Did both characters actively pursue needs?
- Were the roles equally believable?

Two-character bag

Character one *Character two*

Now that you have put your scene on its feet, let's inject a high degree of vocal differentiation. Deepening vocal placement also deepens your acting choices.

Exercise 2.6: Talk This Way, No Talk This Way
fifteen minutes—rehearsal

Use the same script as exercise 2.5. Concentrate on maximizing vocal choices. Pay attention to accents, rhythms, intonation, and pauses. Make sure that you are not relying on your own vocal habits. Please see chapter one, Full Face Masks, Modifying Results, exercise 1.5.

1. Working without the bag, practice the first character's voice. Level 4.
2. Maximize vocal choices. Work through levels 6, 8, and 10.
3. Working without the bag, practice the second character's voice. Level 4.

4. Maximize vocal choices. Levels 6, 8, and 10.
5. Returning to the bag, practice the first voice. Level 8.
6. Turn the bag, drop into the second character, and practice the voice. Level 8.
7. Shift through the scene with maximized voices.

Discussion
- Were you able to maximize vocal choices out of the bag?
- Were these choices sustained in the bag?
- How did maximizing your vocal choices affect the performance?

Exercise 2.7: Vocal Variance
two minutes—performance
Use the same script as exercise 2.5 and 2.6. Choose new voices that do not belong to your family members.

1. Enter as before, with a neutral walk.
2. Perform the family scene using altered vocal characteristics.
3. Shift vocal patterns as soon as the bag is turned.
4. Complete the scene, take off mask, and neutral walk exit.

Discussion
- Did vocal expressiveness increase?
- Was each voice consistent throughout the performance?
- Describe in what ways acting choices were affected.
- How did the scene change?

Create several additional two-character bag mask performances, time permitting.

Hold these bag mask vocal shift exercises close to your heart. They will serve you for future bag exercises and remind you to maximize and clarify vocal choices whenever you act.

CORE EXERCISES: THREE-CHARACTER BAGGING

PHYSICAL SHIFTS

In the following exercises, the primary focus is on delineating clear physical shifts. This does not negate the fine work you have done with vocal variance. Once the physical work is complete, we'll merge body and voice. You can fine tune both elements of expressiveness as your scene progresses.

With three-character bags it is important to take your time developing the performance. Accelerating too quickly leads to inaccurate choices. Practice physical shifts slowly at first. Increase speed incrementally. If your physical expressiveness is slapdash, you are probably attempting to shift gears too quickly.

Note: It is helpful to color-code the inside of the bag. Assign a specific color for each Hu-Bag character. This serves to remind you who is facing the audience.

Exercise 2.8: Three's Not a Crowd

twenty minutes—rehearsal

two minutes—performance

This allows you to focus on physical differentiations between three characters. Create a silent scene with three friends hanging out together (fellow actors excluded). Build a new bag mask for these characters (leave one side blank). As you rehearse, work with a sense of purposeful fluidity. Avoid undue tension and breathe easily throughout. Do not exaggerate the stances. Remain truthful to each character's physical nature.

1. Neutral walk to performance area with mask.
2. Shift into first Hu-Bag stance. Remain fluid in stance.
3. Shift into second Hu-Bag stance. Remain fluid.
4. Shift into third Hu-Bag stance. Remain fluid.
5. Shift between characters several times. Take your time.
6. Complete the scene with three rapid Hu-Bag stance shifts.

7. Neutral walk exit.

Discussion
- Did this performance hold your attention?
- Were the shifts clean? If not: where did the physicality go awry?
- Were certain characters more believable than others? Specify.

Exercise 2.9: Walk This Way, No Walk This Way
fifteen minutes—rehearsal
Stay with the same three friends you used in exercise 2.8. When you perform, remain facing forward and stay in the same spot so that you are walking in place.

1. Working without the bag, practice the first friend's walk.
2. Working without the bag, practice the second friend's walk.
3. Working without the bag, practice the third friend's walk.
4. Repeat all three walks, one at a time.
5. Working with the bag, practice the first walk.
6. Turn the bag, drop into the second character, and practice the walk.
7. Turn the bag, drop into the third character, and practice the walk.
8. Continue to turn the bag and shift walks.

Discussion
- Were the three walks distinctive?
- How were they differentiated in terms of rhythm? Physical placement?
- What could you discern about the characters based on their walks?

Exercise 2.10: Street Scene
two minutes—performance
This uses the walks developed in exercise 2.9 to create a simple physical performance. Continue to walk in place.

One bag: three character walks

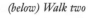
(left) Walk one

(below) Walk two

(left) Walk three

1. Enter as before, with a neutral walk.
2. Perform a scene with the three characters walking down the street. (Shift walking patterns when you turn the mask.)
3. Allow time to establish each new walk.
4. Complete the scene, take off mask, neutral walk exit.

Discussion
- Did physical expressiveness increase?
- Was each walk consistent throughout the performance?
- Discuss how the scene evolved.
- Did each Hu-Bag hold your attention, even without words?

Exercise 2.11: Walking and Talking, Take Three

thirty minutes—rehearsal

two minutes—performance

This merges physical and vocal shifts. Do not rush through this exercise—it presents a higher degree of difficulty. Use the bag mask techniques you have acquired in exercises 2.2 through 2.10. Keep your choices simple and clean.

Choose three new characters and write a nine-line scene (three lines per Hu-Bag).

Sample scene

Moe: Hey Dave! Did you see the game?

Dave: Yeah. It stunk.

Sally: I thought the teams played well.

Moe: Yeah, Sally, you know best.

Dave: I tell ya, Moe, it stunk.

Sally: Well, what do you know about it?

Moe: That's right. You tell him, Sally . . .

Dave: I'm going out to get some pizza.

Sally: See you later, loser.

This sample scene follows a prescribed pattern: A, B, C, A, B, C, A, B, C. Each of the characters follows a logical arc with a clearly scripted beginning, middle, and end. Thus, remembering and performing the sequences should not be difficult. Each character arc can build in intensity.

1. Practice each character's lines out of mask.
2. Practice each character's lines in mask.
3. Merge lines with walks out of mask.

4. Merge lines with walks in mask.
5. Perform the nine-line scene while walking and talking.

Discussion
- Were you able to merge voice and body?
- Were you able to differentiate between the three Hu-Bags?
- Did walks and voices deepen together?
- Was one element more difficult than the other?

Now that you have merged voices and walks, let's add yet another layer: activities.

Exercise 2.12: Simple Activities
twenty minutes—rehearsal
two minutes—performance
Engaging in activities focuses acting energy. Continue with the same characters and dialogue as in exercise 2.11. Instead of walking, imagine each Hu-Bag engaged in an activity. What might they be *doing* while saying their lines? As you begin, concentrate on the activities (the dialogue will follow). Remain truthful to each character's physical and vocal attributes.

A note: This is a good time to add eyeholes, if you haven't done so already. Without them it is difficult to perceive and handle objects. Locating eyeholes when you turn the bag can be problematical. Practice each turn—finding eyeholes and shifting into each character—several times.

Set-up
Place a table in the center of the performance area. Place the objects on the table.

Sample activities

Wringing out a cloth	Talking on the phone
Swatting a fly	Filing nails
Sewing a sock	Licking stamps
Brushing your teeth	Combing your hair

Sample scene

Moe: Hey, Dave, did you see the game?	*Reading a magazine.*
Dave: Yeah. It stunk.	*Combing hair.*
Sally: I thought the teams played well.	*Bouncing a ball.*
Moe: Yeah, Sally, you know best.	*Lowering magazine.*
Dave: I tell ya, Moe, it stunk.	*Pointing with the comb.*
Sally: Well, what do you know about it?	*Grabs ball and tucks under arm.*
Moe: That's right. You tell him, Sally . . .	*Goes back to reading magazine.*
Dave: I'm going out to get a pizza.	*Throws down comb in disgust.*
Sally: See you later, loser!	*Throws ball hard at Dave.*

With a scene like this, you'll have to practice picking your props up and putting them back down on the table. The final ball toss is straight forward, at the audience. For now, we have to imagine how Dave would react. If you were to develop the scene further, you could show Dave catching the ball, or ducking to get out of the way.

Now write your own scene and follow these steps:

1. Working out of mask, one character at a time, engage in a simple activity.
2. Next, practice the activities in mask—one Hu-Bag at a time.
3. Add lines as you continue with the activities.
4. Drop into mask and reconnect with all three Hu-Bags.
5. Practice shifting between Hu-Bags, with lines and activities.

Discussion
- Were the activities sustained for each character?
- How did each activity affect character truth?
- What discoveries did you make about physical placement?

Exercise 2.13: Street Scene with Activities
thirty minutes—rehearsal
three minutes—performance
Now we'll put your three friends out on the streets. They are walking, talking, stopping, and engaging in simple activities. Do not worry about logic (when was the last time you saw someone brushing their teeth outside?) Your main objective is to multitask cleanly.

1. Rewrite your scene and set it on a street.
2. Practice shifting between stances, walks, and activities.
3. Incorporate lines.
4. Practice walking, speaking, and then engaging in simple activities.
5. Adjust the pace to accommodate physical tasks and speaking.

Discussion
- Were you able to merge walks and activities?
- Were vocal and physical attributes deeply etched?
- How did the activities help to enliven each Hu-Bag?
- Ideas for further improvements?

MAXIMIZING AND MINIMIZING

Bag mask performances are improved by maximizing and minimizing physical and vocal characteristics. It is possible, of course, to overemphasize acting choices. If this happens, tone down choices and bring your characters back to reality. Please see chapter one, Full-Face Masks, Modifying Results, exercises 1.5 and 1.6.

Exercise 2.14: More or Less
1. Work with one character at a time.
2. Repeat street scene with walking and activities.
3. Begin at energy level 5.
4. Maximize physical choices to levels to 6, 8, and 10.
5. Minimize physical choices to levels 4, 2, and 1.

6. Maximize vocal choices to levels 6, 8, and 10.
7. Minimize vocal choices to levels 4, 2, and 1.
8. Choose the energy level that best suits each Hu-Bag's body and voice.
9. Shift freely between levels for each Hu-Bag.

Discussion
- What energy levels served each Hu-Bag?
- Were different levels needed for body and voice?
- Were you able to shift between levels in performance?
- How does maximizing and minimizing affect character choices?

Repeat this exercise with future bag mask routines.

IN AND OUT OF BAG MASKS

The following exercises test your ability to maintain specific character choices unmasked. Choose one of the bags that yielded precise results. Review your script for accuracy. Sloppy memorization = sloppy acting.

Exercise 2.15: Bags Away I
four minutes
1. Repeat exercise 2.11, Walking and Talking, Take Three, in bag mask.
2. Now perform the script out of bag mask.

Discussion
- Were you able to repeat your performance in bag mask?
- Were you able to maintain transformation out of bag mask?
- Which performance was more convincing?
- What did you learn shifting between being masked and unmasked?

Exercise 2.16: Bags Away II
ten minutes

1. Repeat exercise 2.12, Simple Activities.
2. Practice this script three times, in bag mask.
3. Now remove the mask and repeat the performance.
4. Alternate two more times—masked and unmasked.
5. Perform in bag mask. Perform unmasked.

Discussion
- Is this performance more believable in or out of mask?
- How does working out of mask inform characters? Vice versa?

Time permitting, repeat exercises 2.15 and 2.16 with additional bag masks.

ADVANCED BAGGING: FOUR CHARACTERS AND BEYOND

COMPLEX SHIFTS

Four-character bags allow you to test your ability to juggle extreme character demands, high emotion, and situation comedy. You will continue to combine physical and vocal choices. The sheer theatricality of playing four characters carries considerable weight. Clean scenes are exhilarating to perform—bliss to watch. The key is to act with intelligence and clarity. Once you become a four-character master, your creative spirit will soar.

Maximize and clarify each new bag mask performance. Then, test your grasp of characters and shifts by working in and out of the bags. Feel free to alter situations and rewrite multiple-character scenarios. Make definitive choices. Push your limits. Test your range.

Exercise 2.17: Shift, Shift, Shift, and Shift
two minutes—performance
This is a primary four-character exercise. Write a new scene with four distinctive characters. Limit each character to three lines/interjections. Create a four-face bag mask. Map your characters' traits

Four-character bag

1. *Little girl*

2. *Brother*

3. *Mommy*

4. *Gramps*

doggedly. Work for agility and precision. Begin slowly. Add tempo after you master individual rhythms, voices, and physicalities.

1. Enter as always, with neutral walk, bag in hand.
2. Shift cleanly into first character.
3. Shift cleanly through all four characters—sequence lines so that you move the bag in one direction (clockwise or counterclockwise).
4. Add walks and activities as appropriate.

Discussion
- Were you able to embody all four characters?
- Are you still shifting with precision?
- What would you do to improve each character in this scene?

Repeat this exercise until you have mastered the performance.

Exercise 2.18: Talk Show

This allows you to explore a four-character scene within a specific framework: a talk show on television. Choose a hot topic. Make sure that your guests disagree. Escalate a word war by raising the stakes. Each Hu-Mask is right. The other three opinions are wrong. Raging conflict erupts.

Try to breathe and stay relaxed inside your bag. Pursue each Hu-Bag's objective without undue physical and vocal tension. When you rehearse the scene, begin slowly. Add tempo by measured degrees.

Sample script flow
Host introduces subject and guests.
Each guest says hello (rapid bag turns).
Host starts discussion.
Guest one pipes in.
Guest two disagrees with guest one.
Host tries to settle argument.

Guest three backs up host.
Guest one argues with guest three.
Guest two argues with guest one.
Host smoothes things out.
Guest three agrees with host.
Guest one and two begin to fight.
Host goes to commercial break.

Discussion
- Was the argument believable?
- Did the escalation of points make sense?
- Which character were you rooting for?
- Were physical and vocal attributes maintained throughout?

A note: Decisive actors use emotion without falling prey to it. This means that you become emotional as a result of pursuing clear-cut objectives. For example, if you obtain your objective you might become happy, exhilarated, or satisfied. If you lose you might become frustrated, angry, or sad. But you do not begin the scene by having to cull these emotions from the depths of your soul. They surface as a direct response to what you win or lose.

Exercise 2.19: New Place, New Characters
thirty minutes—rehearsal
three minutes—performance
Select a locale you have not yet inhabited in mask. Choose character types you have not yet portrayed. Practice the scene with precise physical, vocal, and psychological shifts.

Sample locales

Bar	Fifth-grade classroom
Park bench	Grocery store
Airport security checkpoint	Sidewalk café
Laundromat	Television repair shop
Bus	Football stadium

1. Choose a locale.
2. Decide on four characters that would inhabit this locale.
3. Build a new bag mask featuring the four characters.
4. Integrate all four characters into the scene. Make sure you know why each of them is there. Justify every line.

Discussion
- Did each character have a clearly defined objective?
- Was the environment maintained throughout?
- What surprises would you add to keep the Hu-Bags on their toes?

Exercise 2.20: Fight Night!
forty minutes rehearsal
two minutes—performance
This heightens stakes, pace, and emotion. As always, work to focus each character with specificity. Do not allow the emotion of the scene to muddy physical or vocal articulation.

1. Write a four-person scene with an explosive argument.
2. Include a series of *rapid* interjections between all four characters.

Discussion
- Was each character physically and vocally consistent?
- Did the fight progress with clean, focused shifts?
- Was emotion controlled? Did it shift throughout the scene?
- Was there a coherent build as the fight reached its climax?
- Was the entire performance believable?

If you can only get through the scene once (without becoming tongue tied or tension bound) then you have not mastered the exercise. Repeat the exercise until you have mastered each piece of action. With difficult exercises such as this, repetition always improves acting.

Exercise 2.21: Speed, Speed, Everything's Speed

Return to the same script and bag used in exercise 2.19. Work for increased speed. Master each vocal and physical shift through diligent repetition. Do not garble a single word.

1. Heighten the stakes for each character.
2. Increase the pace of the scene accordingly.

Discussion
- Was clarity maintained?
- What speed works best for this scene?

Exercise 2.22: Ages of Life

forty five minutes—rehearsal
three minutes—performance

Now you can test your ability to play a wide range of ages. Be sure to affect complete transformations for each of the Hu-Bags.

1. Develop a family scene and mask that incorporates these characters:
 Baby
 Teenager
 Parent
 Elder
2. Work through physical shifts first.
3. Next, incorporate vocal shifts.
4. Finally, add activities.
5. Check the scene for logic.

Discussion
- Was the challenge met?
- Which physical and vocal attributes were clearly delineated?
- Did one age stand out above the others? Why?

Exercise 2.23: Along Came Spot
You can create a five-character scene by utilizing the top surface of the bag. It is somewhat less complex if this fifth character is an animal. Choose a simple beast, for example, a dog that woofs, a bird that chirps, or a monkey that just stares out at the proceedings.

1. Add an animal to the top of your four-face bag.
2. Integrate the animal into a five-character scene.

Discussion (review of key questions)
- Did the neutral walks frame the monologue?
- Was the actor commenting on the work during entrance or exit?
- How thorough was the initial shift into Hu-Bag character?
- Was each character believable?
- Did the actor sustain physical and vocal clarity?

Exercise 2.24: Mob Scenes
Make sure you understand the script and are listening to your partner. Work collaboratively as you make decisions. Allow room for discoveries and changes. Remember to face the audience, not your partner. Try the following:

- Four-person scene with two actors using two-character bags.
- Six-person scene with three actors using two-character bags.
- Six-person scene with two actors using three-character bags.
- Eight-person scene with two actors using four-character bags.

From this point on, creating new scenarios is a matter of time, inclination, and inspiration. Tackling multi-character scenes is best accomplished one step at a time. Work collaboratively with your partner(s) to determine who is in the scene and what each Hu-Bag must say and do. Clarify objectives and obstacles. Master four-person scenes before moving to six. Listening intently is the key to handling the mayhem. So too are crisp bag turns, precise actions, and, as always, clean acting shifts.

APPLIED BAGGING

JOKES

A logical starting point for applied bag masking is joke telling. Jokes present tremendous acting challenges. You must have command of the script. The story must be told with commitment. Details are critical. Results are immediate: If the audience laughs, you told a good joke well. If you are met with silence or groans, you have either told a bad joke, or told a good joke badly. In either event (unless your audience has no sense of humor) you can immediately gauge your joke-telling skills.

You will need a good joke with multiple characters. If you examine a knock-knock joke, for example, there is only one character—you, the narrator of the joke. In multiple character jokes, the narrator counts as *one* of the characters you play, but there are additional characters as well. Here is a classic four character joke, abbreviated:

Narrator: A guy walks into a bar with his dog. He says to the bartender:
Dog owner: If I can make my dog talk, will you give me a beer?
Bartender: Sure, buddy. I have never heard a dog talk before.
Dog owner: Fido: Who is the greatest baseball player of all time?
Fido: (Barking) Ruuuuuuffff! (Meaning Babe Ruth.)
Bartender: Okay wise guy! Get outta here, and take your stupid dog too!
Narrator: The owner and the dog are thrown out on the street. They walk along and Fido says:
Fido: Maybe I should have said Joe DiMaggio.

Exercise 2.25: Joking Around
Find a multiple character joke. Memorize each character's lines, in sequence, word for word. Make a bag mask that contains all four characters.

1. Practice telling the joke in bag mask.
2. Work for clean shifts between characters.

3. Maximize vocal and physical differences between characters.
4. Perform the joke in bag mask.
5. Take a moment to return to neutral. Remove the bag.
6. Tell the joke again without the bag.
7. Maintain choices used in the bag.

A note: Jokes are never as funny when told the second time around. Do not be overly concerned if you receive fewer laughs when repeating the joke. Concentrate instead on your ability to transfer bag mask techniques to non-masked performing.

Discussion
- Were the characters clearly delineated in the bag mask?
- Were they just as clearly delineated out of the bag mask?
- In what ways did the bag mask help you to perform the joke?

Repeat with several new jokes. Try shaggy dog stories to test your ability to sustain multiple characters over long periods of time.

COMPLEX SCRIPTS

You can construct and use bag masks for scripted monologues in diverse plays. For example, Launcelot Gobbo in Shakespeare's *Merchant of Venice* delivers a wonderful shift monologue in act 3, scene 5.

Exercise 2.26: Launcelot Gobbo
Launcelot is struggling to decide whether to continue serving his cruel master, Shylock, or run away. He grapples with his inner angel and devil. These opposing forces are battling for control over his conscience. You will need a three-character bag for this monologue. Portions of the script demand rapid shifting. Use extreme physical and vocal choices for fiend and conscience. The following lines have been broken in order to indicate shifts.
Enter Launcelot Gobbo (the clown) alone.

Certainly, my conscience will serve me to run from this Jew my master: the fiend is at mine elbow, and Tempts me, saying to me,	*narrator*
"Gobbo, Launcelot Gobbo, good Launcelot," or "good Launcelot Gobbo, use your legs, take the start, run away."	*fiend*
My conscience says	*narrator*
"No; take heed honest Launcelot, take heed honest Gobbo,"	*conscience*
or as aforesaid	*narrator*
"honest Launcelot Gobbo, do not run, scorn running with thy heels."	*conscience*
Well the most courageous fiend bids me pack,	*narrator*
"Fia!	*fiend*
says the fiend,	*narrator*
"away!"	*fiend*
Says the fiend,	*narrator*
"for the heavens rouse up a brave mind!"	*fiend*
Says the fiend,	*narrator*
"and run."	*fiend*
Well my conscience hanging about the neck of my heart, says very wisely to me:	*narrator*
"My honest friend Launcelot"—	*conscience*
Being an honest man's son, or rather an honest woman's son, for indeed my father did something smack, something grow to; he had a kind of taste;—Well my conscience says	*narrator*
"Launcelot budge not!"—	*conscience*
"Budge!"	*fiend*
Says the fiend,—	*narrator*
"Budge not!"	*conscience*

Says my conscience. "Conscience" *narrator*
 Say I, "you counsel well.—Fiend" say I,
 "you Counsel well," . . .

1. Build a three-face mask featuring:
 - Launcelot as narrator
 - His fiend ego
 - His conscience ego
2. Practice the monologue with precise bag mask shifts.
3. Work in and out of the bag mask.

IN CONCLUSION

Reflect on the myriad ways you have learned to shift. You are aware of vocal and physical differentiation. You are more expressive in each of these key areas. You are adept at adding surprises to your performances. You are capable of making your work deeper, cleaner, and thus more articulate. In addition, your creative forces are fully engaged. You have built masks and created scenes. Then, you altered the scenes midstream. You played with emotion and tempo, and learned to control them. Finally, you continued to stretch your range of character types in and out of mask.

Your newly acquired bag mask skills will imbue your acting with purpose and precision. This is true for masked and unmasked plays. You are a more versatile actor than when you strolled to the store and found your first bag. Put some groceries in that bag and shift your way over to clowning.

CLOWNING

OVERVIEW

Oh noble fool!
Oh worthy fool! Motley's the only wear.
 —*Shakespeare,* As You Like It

Clowning is a unique means of training actors. The work is based on several components of high-level acting: connection, risk, heightened stakes, vulnerability, and positive choices. How does clowning introduce and reinforce these key acting techniques?

The process is direct:

1. Audience connection begets risk;
2. Risk begets heightened stakes;
3. Heightened stakes beget vulnerability;
4. Vulnerability begets positive choices;
5. Positive choices beget a new round of risk.

This acting cycle is designed to bring you face to face with your singular clown essence. Once your essence has emerged, you can bring your clown to play in a myriad of theatrical situations. Compelling actors begin to integrate risk and vulnerability in rehearsal and bring them to fruition in performance.

Risk is central to the human condition. Great theater, inasmuch as it reflects our lives, addresses risks. In plays from ancient Greece to contemporary America, characters must fight to achieve their dreams. The potential for a character's success or failure—especially in high-stakes situations—rivets us to the action.

A serious problem for many actors is that real life teaches us to avoid taking undue risks. We have become adept at minimizing our losses—nobody wants to play the (real) fool. Of course, characters in plays are often foolish, encountering severe setbacks as they struggle to achieve immediate and long-range goals. Clowning induces risk-taking by allowing actors to put their hearts on the line. And come what may, clowns never just roll over and suffer consequences. They never wallow in defeat. Rather, they outfox potential failure. They joyfully put their worst foot forward. Clowns risk, fail, dust themselves off, and try again. Are you ready to bare *your* artistic soul? Find a red nose and get ready to play.

TERMINOLOGY

A *clown* reflects the persona of the artist's inner child.

The clown *essence* is comprised of primary personality traits.

Yes-mode is a state of pure positivism wherein the clown accepts everything that happens.

High stakes raise the importance of achieving objectives.

Risk permits the clown to attempt the impossible.

Failure occurs when the clown cannot achieve what it sets out to do.

Vulnerability reveals the clown's deepest feelings during moments of failure.

ESSENCE

A primary objective of clowning is to find your singular clown essence. Discovering the precise nature of this essence deepens your ability to open your heart and act with passion. Injecting your

essence into conventional theatrical roles—for serious as well as comic plays—widens your range of active and reactive choices.

Your clown essence is intrinsically linked to your "inner child." In preparation for clowning, take a moment to consider your earliest states of being. What were you like as a child? Were you truculent or goofy? Loved or forlorn? Gregarious or introverted? Energetic or sluggish? Silly or serious? Your nascent characteristics will be deeply connected to your specific clown persona. This persona will be clarified through active engagement in clowning exercises. There is little point in attempting to alter your results. Rather, step aside, knowing before you begin that the little child in you is about to be reawakened. Clowning taps you (the real you) on the shoulder and extends an open invitation to play.

Most actors embark on their essence quest by trying to be funny—clowns are supposed to be funny, right? Well, not necessarily. There is nothing to be gained by attempting to pour you into a Bozo mold. In fact, prescribing a particular clown essence is a sure way to ruin clown instincts. Clown essences comprise a kaleidoscopic range of qualities. Your essence might be lonely, hopeful, thoughtful, shy, sad, mischievous, poignant, romantic, or just plain dumb. Your clown might have important things to say about the human condition or, conversely, find fulfillment watching the world go by. In any event, your essence is probably not pure silliness—in which case, all the silliness in the world will not bring your essence to life. Drop conventional notions concerning clowns and clowning. Do not lose sleep worrying about how funny you are. To be sure, laughs can boost your comedic ego (and you will get your fair share of laughs), but keep in mind that funniness is not the primary objective of the work.

A note: Many actors who claim to have no sense of comedy often develop hilarious clown essences. Others who consider themselves naturally comedic are confounded by the seriousness of their work. It is best to approach clowning with an open mind. Allow yourself leeway to find, refine, and perfect your distinctive clown essence.

STUDIO SET-UP

Take time each day to prepare the studio. This eliminates distractions and promotes each actor's finest clowning efforts.

- Keep the studio tidy.
- Set up chairs along one side of the room so that watchers can sit together in a single row. This supports strong performer/audience connection.
- Set up a masking flat with a mirror on the back.
- Noses are put on and taken off behind the flat, out of audience view.
- Use the flat for entrances and exits.
- Props are placed in the performance space prior to exercises.

AUDIENCE

The "audience" is comprised of fellow actors and coaches who are watching your clown routine. They are a necessary component of the work; without them you cannot share discoveries. When you are clowning, it may seem as though you are on stage, even though you are in the studio fulfilling a simple exercise. Each exercise offers an opportunity to confront and handle performance pressure.

When you are watching a clown, pay close attention to each evolving moment. Watchers learn as much as performers. Combining the two perspectives is revelatory.

LAUGHTER

As audience members, it is important to be honest in your reactions to the clown. Do not laugh when the clown is not funny. Mercy laughter is detrimental; clowns need to know when they are funny and when they are not. If the clown is poignant, for example, remain silent and watch, or enjoy an internal chuckle. Silence can

instigate failure—a worthy state of being for emerging clowns. Your honest reactions will be factored back to actors during post-clowning discussions.

THE NOSE KNOWS

Clowning exercises begin with the mask itself: a traditional clown's red nose. Let's consider this nose for a moment. Is it a mask? We don't tend to think of clowns as performers wearing masks. Although it is relatively small, the clown nose *is* a mask: a partial-face mask. Don't be fooled by this terminology; partial masks have just as much power as their larger cousins. Clown noses are as transformative as full-face masks, as shifty as bag masks, and as playful as half-face masks.

A clown nose affects actors in curious ways. Since the nose leaves most of your face unmasked, you are free to express reactions, thoughts, and emotions with your own eyes, eyebrows, forehead, cheeks, and lips. You'll feel more exposed as a clown than as a character in a larger mask. It's really *you* performing up there. You know it and the audience does, too. That is at least part of the reason the work is exhilarating. You—as actor and clown—are free to express the most truthful aspects of your personality.

Clown noses differ from full-face and half-face masks inasmuch as they are not imbued with inherent traits that are identifiable before the work begins. That same red nose has a different effect on every actor that wears it. Therefore, it is impossible to predict where clowning will lead you. You can't sit in your living room and map your clown essence. You shouldn't even try; your cleverest ideas will backfire. The only way to learn how to clown is to plunge into the exercises, nose first.

Finding a Nose

- You can find clown noses at local comedy and costume shops.

- Look for the soft plastic variety (hard plastic cuts the skin at the base of your nose).
- Your clown nose should be bright red, with breathing holes on the bottom.
- Hot glue or sew elastic bands to the sides of the nose. This prevents it from slipping when you become a sweaty fool racing around the studio.

COSTUMES AND PROPS

Choosing costume pieces and props is left to your discretion. Keep things simple; many actors overdress/prop themselves in the hope that layers of stuff will somehow keep the act afloat. A simple hat will suffice. Wear shoes that are practical and serve you. For example, if you need traction, wear sneakers. If you need to slip around the stage, wear socks.

CORE EXERCISES: BASIC CLOWNING

RULES

There are two golden rules of clowning:

1. *You must not talk or make sounds.*
2. *You must always stay in yes-mode.*

If you follow these rules your clown will soar. If you break them you will be put in the clown stocks and subjected to public humiliation.

LET'S FACE IT

The best way to commence clowning is to put on the nose and experiment with faces. You will find that shifting facial expressions puts

you (as opposed to a character in a play) at the core of the work. Don't fight this. Embrace the duality: you as clown, clown as you. At this formative stage of the process, try to follow your instincts and remain open to discoveries. You may be surprised to find that specific expressions consistently evoke audience response.

A note: In order to avoid violating the properties of the mask, always put on the nose behind the flat (out of audience view), facing away from the mirror. This gives you time to drop into your clown before beginning your performance. Likewise, remove the nose behind the flat, after exiting as your clown.

Exercise 3.1: Face Play
five minutes

1. Stand in neutral-ready, facing away from the mirror.
2. Put on the nose and adjust strap and hair.
3. Turn to face the mirror.
4. Slowly allow your face to melt from one expression to the next.
5. Choose a face and enter the performance space.
6. Slowly shift facial expressions.
7. Choose your most effective expression. Stay with this expression for one minute.
8. Exit as the clown you have become.
9. Look at your clown in the mirror.
10. Turn away from the mirror and take off the nose.

Discussion
- What did you discover when you looked in the mirror before performing?
- Which expression did you choose for your entrance? Why?
- How did the audience react to facial shifts?
- Which face seemed to best fit your clown?
- What did you discover when you looked in the mirror after performing?

Face one

Face two

Face three

Notice how the clown above is transformed through facial expressions. Each of these faces will come into play during subsequent clowning routines.

CONNECTION

During exercise 3.1 you sensed the power of sharing facial shifts with your audience. This connection is critical and must be maintained. Groans, applause, and laughter provide fuel for original ideas. They inspire clowns to continue seeking approval, taking risks, and developing new routines.

Whenever you are clowning, remember to share your innermost thoughts and revelations with the audience. This is not an option. You *must* maintain this connection. If it is broken, your clown becomes isolated and performs for selfish reasons. Truly magnanimous clowns share discoveries as a matter of course. Therefore, whether

you are dancing, climbing a wall, baking a cake, or picking your nose, share your innermost feelings and thoughts.

How should you begin to connect? To start, summon the courage to face your audience and make direct eye contact. This does not mean staring people down. It means using every fiber of your face and body to express yourself. It means actively sharing each moment of desperation, failure, success, frustration, and elation. Clowns find completion through this union. Thus, successful clowning is synonymous with a highly developed sense of generosity.

A note: Establishing audience connection is easier said than done. If you are like most thespians, you have not encountered many opportunities to practice the technique. Naturalistic scenes (standard, in most acting classes) force you to ignore the audience and focus on acting partners. It's considered bad form to look directly at your auditioners when auditioning. So, do not be surprised if connecting with the audience feels peculiar at first. Once you are flexing your connection muscles on a regular basis, it becomes second nature.

Exercise 3.2: Three-Face Connection
five minutes
This allows you to engage in a simple acting task while remaining connected with your audience. Concentrate on shifting cleanly (as in bag masks). Share each face openly and honestly.

1. Enter as clown and sit in a chair.
2. Connect with your audience.
3. Shift between three faces—fifteen seconds per face.
4. Repeat and share shifts and faces with the audience.
5. Exit with final face.

Discussion
- When was audience contact initiated?
- How well was the connection maintained?
- Were there moments when the clown lost the audience? How did this happen?
- Which face seemed most connected?

Exercise 3.3: Activity Connection

ten minutes

Maintaining outward focus becomes less and less daunting with practice. Engaging in an activity gives you something tangible to share. Feel free to use a simple prop, as needed. Do not become immersed in your activity to the exclusion of your audience. Remember to look out on a regular basis. Let everyone know precisely what is happening on stage. Share decisive moments—these will become high points of the performance.

1. Enter as clown.
2. Perform a simple activity, for example:
 - Folding a newspaper into an origami bird.
 - Blowing bubbles with five pieces of gum.
 - Tying your shoelaces into a quadruple knot.
 - Combing your hair in all directions.
3. Share each moment of discovery with the audience.
4. Take a bow and exit as clown.

Discussion

- Did your clown connect with the audience?
- Were you able to share the activity openly and honestly?
- What discoveries did you make about connecting with the audience?

Notice how the clown below shares his discovery with you. He has fashioned a newspaper bird and invites you to help celebrate the joy of its creation.

YES-MODE

Yes adv. Exclamation. Used to give an affirmative response. Expressing delight.
—The New Oxford American Dictionary, *2001*

Many outstanding clowns are defined by an intrinsic sense of hope. Even in the face of shattering adversity, they retain an innate sense

Folding an origami bird with newspaper

of positivism. One way to ensure that you make positive choices is to act in yes-mode. This means accepting what happens to you on stage and moving forward with your act. Since your clown (as governed by the rules of clowning) is not permitted to talk, you must find ways of saying "yes" with your face, body, and attitude. The moment you reject an idea, the possibility of incorporating it into your act is

negated. In other words, when you say "no," creative options are nullified. On the other hand, accepting an offering—even if it is not asked for, expected, or wanted—leaves creative options open. Thus, yes-mode clowning (and yes mode acting) ensures high levels of artistic expression.

If your clown falls prey to negativity, you have two choices:

1. Give up—your routine is dead.
2. Snap out of it. Immediately drop back into yes-mode.

You must train yourself to avoid negativity. Otherwise, no-mode choices will kill your clown. This doesn't mean that you have to roll over and accept what fate decrees. By all means, fight for your clown's life. Fight those who would knock you down. Fight those who would pin you beneath the weight of their logic. But retain a positive attitude throughout that good fight. Imbue your work with irrefutable positivism.

Spotlight: Charlie Chaplin

Charlie Chaplin, one of the twentieth century's great clowns, was a shining example of yes-mode clowning. The misfit tramp never gave up. His unflagging optimism kept him afloat as the world fell to pieces around him. Witness the hero in *The Gold Rush* starving in the frozen Klondike, eating his leather shoes and relishing the flavor of each dirty lace. Chaplin's resolve gave him strength to battle the evil forces of industry in *Modern Times*. In *City Lights,* he loses the love of his life but never, ever ceases trying to win her back. Chaplin's positive actions endeared his clown to the audience and kept his films alive.

Exercise 3.4: Yes, It's Dumb. Isn't That Great?
ten minutes

This tests your capacity for remaining in yes-mode while doing stupid things. Do not rehearse the activity before performance. Take a really dim-witted idea—

- Blowing bubbles with popcorn.
- Changing faces behind a scarf.
- Stupid magic tricks.
- Drawing pictures with crayons.

—and use it as an opportunity to test your affirmative attitude. Continue to connect with the audience throughout.

1. Enter as clown.
2. Engage in a really dumb activity.
3. Remain in yes-mode as you connect with the audience.
4. Take a bow.
5. Exit as clown.

Discussion
- Was the idea really dumb? Were you embarrassed to perform it?
- Did you stay in yes-mode?
- Did negativity rear its ugly head? At what precise moment?
- Does this dumb idea contain the seed for a brilliant clown act?

Exercise 3.5: Interview Contradictions—Yes-Mode Test
fifteen minutes
This is a core clowning exercise. Can you remain positive in the face of adversity and graciously accept what happens? The more things fall apart, the more you must lock into yes-mode. Trust in the power of the red nose. Leave your careful mind behind. Answer each question as truthfully as possible. Remember, no talking.

1. Clown enters and waits for instructions.
2. Clown agrees to whatever coach says.

Side Coaching
- Engage the clown in "conversation." Test yes-mode by inducing contradictions.

- Phrase every direction in the form of a question, okay?
- Ask impossible questions that would normally require a negative response.
- Create contradictions.
- Keep asking the clown how it's going (according to the rules, the clown must agree it's going well).
- Catch the clown talking. "Did you just talk, clown?" (Clown must nod.) "You know that's against the law." (Clown must agree.)
- Zero in on any potential negativity.

Sample questions

Hello, Clown, how are you today? (Wait for physical response.)

Do you feel good today? Why?

Do you feel bad today? (Clown must shift to feeling bad.) But you said you feel good. (Wait for response.) Do you feel good and bad? How can that be?

What's the matter now, Clown?

Are you a crazy clown? Are you a serious clown? But you said you were crazy. How can you be crazy and serious at the same time?

Are you a stupid clown? Are you smart? (Wait for shrug and response.)

Continue to harass the clown, as you see fit.

Discussion

- Was the clown buoyant throughout?
- What happened when the clown slipped into negativity?
- What improved when the clown said "yes"?

A note: Stay in yes-mode throughout the remainder of these exercises. Doing so will lead directly to heightened vulnerability and positive choices. Remember that anything you deny will come back to haunt you. If you sweep something under the carpet, actively acknowledge that it is there. Pretending otherwise eliminates the possibility of righting a wrong. That is one less creative opportunity to enjoy. Clown wisdom accepts human flaws.

ESSENCE

Essence n. *The intrinsic nature or indispensable quality of something, especially something abstract, that determines its character.*
—The New Oxford American Dictionary, *2001*

ESSENCE IN ONE WORD

At this stage of the process, your individual clown essence is emerging. In order to isolate and clarify your essence, the audience must take an active role in post-exercise discussions.

Each watcher chooses one word that accurately defines that clown's essence. Crystallized feedback prevents discussions from degenerating into detrimental overanalysis. The word must encapsulate some aspect of the clown's persona. Nothing more or less. As you will find, choosing only one word forces thoughtful analysis and accurate description. In addition, one-word responses are easily recorded and remembered.

Here is a sample set of descriptive words from ten watchers.

I thought your clown essence was:

Eager	Smarty-pants
Untrustworthy	Quick
Crafty	Slippery
Aggressive	Hungry
Purposeful	Sly

Each word points to a precise aspect of the clown's qualities. Taken as a whole, the words paint a comprehensive clown picture (taken singly, the picture is incomplete). Keep in mind that your first set of words is just that: a first set of words. Your essence will undoubtedly change in time; each exercise provides gains and losses in confidence, energy, risk, vulnerability, and creativity. Diligently record each word used to describe your essence. Take particular note of words that are repeated: These are zeroing in on the true nature of

your clown. It is possible—whether you agree or not—that a specific word perfectly captures your essence. Write that word down and paste it on your forehead.

DEEPENING CLOWN ESSENCE

Now that you have begun to experience your clown essence, let's deepen it. Exercises 3.6 through 3.9 continue to test your clown mettle in a series of divergent situations. Approach this process with pervasive positivism and an increased willingness to fail. Pay attention to post-performance one-word essence descriptions. Your essence will be magnified step by step.

Exercise 3.6: Essence Dance
ten minutes
Most clowns love to dance. Sometimes this dance is near the surface of your essence, sometimes it is buried deep within your heart. Whether you are a ballerina, tapper, or have two left legs, dancing has the potential to convey profound clown truths. As always, share your innermost feelings with the audience. Do not apologize for the uniqueness of your dance—it is just as valid as another clown's.

Finding Music
Music is liberating when the rhythm and melody matches your clown essence. There is no telling what type of music will best suit your act. Your clown's musical taste might be rooted in jazz, classical, rock, new age, country Western, bluegrass, gospel, blues, or folk.

Do you have an image of your dance occurring in a certain setting? What music might be playing there? Listen to sounds that are beyond personal (actor) tastes. Borrow CDs from friends or the library. Listen to a wide array of instrumentations. There is no harm in dancing to music that does not work. Toss unusable melodies out the window and continue searching. When you hear the right music you (the clown in you) will know.

Rehearsing and Refining Your Clown Dance

- When you have found your clown groove, put on the nose and move spontaneously.
- Let your dance evolve according to your clown's instincts. Don't push it. Let your clown take the lead.
- If the dance is surprising to *you* it will surprise your audience as well. Great clowning is audacious. Do not shy away from wild choices. Your dance might be one that has never been seen (or even imagined).

Exercise 3.7: Dance Performance
five minutes

1. Enter as clown.
2. Take initial dance position.
3. Music begins (CD or tape player).
4. Dance. Stay connected with your audience.
5. Complete dance, bow, look into your audience, and dance exit.

Discussion

- Did the dance move you?
- Were you connected with the audience?
- Did the dance reflect the clown's essence?
- What were the best moments?
- Again, each audience member describes the clown in one word.
- Has the essence solidified? Has it changed?

A note: A gifted dancer may wind up with an uncoordinated clown. Clumsy actors occasionally develop graceful routines. This is just one of the ways that clowning stretches actors in divergent directions. Do not be surprised if you have a hidden Baryshnikov, Michael Jackson, or Daffy Duck waiting to hit the dance floor.

ESSENTIALLY STILL

Perpetual activity is difficult to control and nearly impossible to watch. Actors who are always in motion have the misguided notion that they must do, do, do in order to be funny, funny, funny. In clowning, and in most other forms of acting, nothing could be further from the truth. Novice clown performances are undermined by an overabundance of energy that is impossible to sustain. Performers and audience members become bored. Alert stillness, on the other hand, offers time to absorb events, process discoveries, connect with the audience, and figure out what happens next. These moments are filled with buoyant potential.

Spotlight: Buster Keaton

Buster Keaton, a clown/actor during the silent film era, was a master of stillness clowning. He balanced and sustained acrobatic acts with alert moments of focused tranquility. A brilliant stuntman in his own right, Keaton never raced from one stunt to another. He savored each moment, taking whatever time he needed to process fellow actors, events, and surroundings. During pauses he connected with his audience. Thus, although he was a man of action, his clown was essentially still. Check out the final scenes in *Steamboat Bill,* as he staggers through a howling storm, the world literally flying around him. Houses, trees, and rivers threaten his life, yet he absorbs each moment with heroic stillness. He faces his demons by quietly walking through the hurricane. At the height of the action, Keaton stands in front of a three-story house. The front side of the house literally crashes down around him as Keaton stands still—absorbing each moment of mayhem—perfectly framed in the fallen attic window. He looks straight at the camera, connecting with his audience. This sequence of events involves risk, vulnerability, connection, and intense stillness.

Using your clown dance as a base, the following three exercises invite you to convert physical motion into applied stillness.

Exercise 3.8: Minimized Dancing
five minutes

Take your dance, isolate it, and distill your clown essence. Using the same music and rhythmic choices:

1. Dance with just your toes.
2. Dance with just your fingers.
3. Dance with just your eyes.
4. Combine two body parts.

Discussion
- Did minimization strengthen the dance?
- At what point did the performance command attention?
- Describe the clown in one word.

Exercise 3.9: Stop Dancing
five to ten minutes

This provides an opportunity to find stillness in the midst of extreme physical exertion.

1. Enter as clown and begin dancing, as before.
2. Become very still in specific dance positions.
3. Connect with the audience. Express your feelings.
4. Continue dancing. Find new positions.
5. Hold final position, bow, and exit.

Discussion
- Which positions garnered audience response? Why?
- Did particular moments seem to express the clown essence?
- Describe the clown in one word.

Exercise 3.10: Solo Statues
fifteen minutes—rehearsal
five minutes—performance

It is possible to further deepen your essence through statues. Dropping into statues clarifies specific facets of your persona. (Please see exercise 1.9: Statues.) You need do little more than think, dream, adjust, or plan. Alert stillness focuses these moments and brings your essence to life. Do not use music. Work for purity of essence. Be still without becoming frozen. Keep each statue energized as you shift fluidly from one position to the next.

Rehearsal
1. Stand in neutral-ready, put on nose, and turn to mirror.
2. Allow your face to shift through several expressions.
3. Find the expression that embodies your clown at this moment.
4. Shift your body as you flesh out the essence.
5. Statue into the mirror.
6. Move to another expression.
7. Physicalize and statue.
8. Drop into one more statue.
9. Turn from mirror and take off the nose.

Performance
1. Enter and find first statue.
2. Connect with the audience. Share your inner thoughts.
3. Shift into new statues. Take time to hold the moment before moving forward.
4. Remain connected through the last statue.
5. Bow and exit.

Discussion
- Were you able to find and complete each statue?
- Did the clown essence deepen in a particular statue?
- Which statue best personified the clown?
- Describe the clown in one word.

Remember the importance of stillness as you accept what happens and open yourself to the audience.

RISK

Risk v. *To act in such a way as to bring about a fortunate or unfortunate situation.*

—The New Oxford American Dictionary, *2001*

What does it mean to take performance risks? Do you have to jump through windows, swallow knives, or withstand verbal abuse? Let's hope not, otherwise there wouldn't be many actors around to train as clowns. Clowning should never include risks that result in physical or mental injury. For example, clowns who trade punches are skilled combat artists. We laugh because we know the actor is not actually at risk—real danger never enters the equation. In clowning, risk implies a willingness to try something that cannot be done. In the process you risk looking foolish—being labeled a fool. In a sense, what you risk is your ego. Risky actors put personal pride in the back seat. This paves the way for superlative clowning.

A note: You always have options when you clown. You can take a risk or you can play it safe. It takes guts to risk—there is the possibility things will fall apart. If you fail, or you think you have failed, do not construe it as a lack of talent on your part. Failure invites intrinsic rewards. And brilliant clowns do not dwell on failure for long—their positivism leads to renewed success. Keep in mind that getting things right is boring. Take risks, mess things up, be willing to look bad, and use clown logic (human illogic) to dig your way out of whatever hole you are in.

Exercise 3.11: First Audition
fifteen long minutes

This exercise brings to mind the actor's nightmare, which could in this case be renamed the clown's dream. You are up on stage and have no idea what is going on. What are you doing up there? How can this have happened? How will you survive this trial by fire? You

will find inspiration at the precise moment things go awry. Put your heart on the line. Believe in the audition. Try with all your might, even though your ship is sunk before you can set sail. Choose something that you honestly stink at. Make sure you can't possibly pull it off, for example:

- Playing a complicated musical instrument (if you have no musical training).
- Tying and untying impossibly tricky knots (unless you are a girl/boy scout).
- Gymnastics (if you flunked swinging in kindergarten).
- Jumping rope (if you are an uncoordinated jumper).
- Dancing with your thumbs (unless you are a thumb-dancing expert).

1. You are a world-famous clown with a world-famous routine.
2. You are auditioning for a great circus that pays well.
3. It's a good job and you need it—you are flat broke.
4. You have two minutes to audition.
5. Choose an act you cannot do.
6. Add a costume that is completely ridiculous and makes you feel stupid.
7. Absolutely no talking, music, or sound effects.
8. You must stay in yes-mode and connect with the audience.

A note: This is an especially difficult exercise to rehearse. Do not over-prepare; you might get too skilled for your own good. Reminder: Clown smart = people stupid.

Discussion
- How fearful were you coming in to audition?
- How did this fear trigger your clown?
- How did risk, fear, and possible failure fuel your clown?
- Describe the clown in one word.

Impossible act: jumping a hurdle on a toy horse

RAISING THE STAKES

Heightened stakes—I *must* juggle these sixteen watermelons and will risk the humiliation of dropping them all over the pristine studio—ensures eventual success. It may seem insane to raise the stakes but that is precisely what motivates a clown to push through failure in order to bask in glory. The moment stakes are lowered, your clown loses momentum. You may as well pack up the watermelon and head for home—the act is over. Therefore, do not run from failure—jump through it, around it, or over it. Your keenest clowning moments await you on the other side.

Moving through failure is central to the human condition. It is a humbling and humanizing experience. We know this from infancy. Trial and error taught us to walk; we grabbed a chair, pulled up, and staggered around until our butts hit the floor. These moments of try-

ing, failing, and trying again merited parental cheers and laughter (one reason we enjoy clowning as adults). Learning to walk was a high-stakes venture (imagine *not* learning to walk). So it is with clowning: Raise the stakes, confront failure, stay positive, and move toward success.

Like Lucy, you need high stakes in order to achieve magnificent failure. The more you risk, the more you have to lose. If you fall, dust yourself off, get up from the floor, and try, try again.

Spotlight: Lucille Ball

Some of our preeminent clowns based their acts on failure and success. Lucille Ball, perhaps the greatest female clown of the twentieth century, forever teetered on the brink of disaster. For example, her television character, Lucy, never relinquished hope that Ricky would let her sing at his club, the Tropicana. In Lucy's mind, performing in the Tropicana spotlight was her path to stardom. When she finally gets her moment to shine, she can't hold a note. Baffled, she misses cues, forgets the dance, becomes self-conscious, and, adding insult to injury, finds herself wearing the wrong costume. Fueled by the very real threat of disappointing her spouse (or at least landing him in hot water) Lucy pulls her act together. Her high-stakes triumph wows the skeptical patrons and her astonished husband.

Lucille Ball concocted the perfect recipe for clowning: high stakes, impossible tasks, and success through mistakes. She knew, coming in, that it would be a rocky road. She also retained the promise of her dream. Stardom was within reach. Lucy never lowered her stakes and she never gave up.

Exercise 3.12: Second Audition
ten long minutes

The set-up for this exercise is the same as for exercise 3.11. But this time around, the stakes are raised through brutal side coaching. It doesn't matter that you know the intervention is coming. Simply pursue your objective: You *must* get this job in the circus. Stay in yes-mode. The circus owner holds the purse strings and is always right.

1. Re-audition with a higher degree of desire for the job.

2. Same rules apply: Two minutes, no talking, yes-mode.
3. Find an even more ridiculous act.
4. Add a new costume element or prop.

Side coaching

The coach, as circus owner, plays a critical role:

- Engage the clown in conversation.
- Tank the clown at all costs.
- Make sure the clown doesn't speak or make sounds (jump on that).
- Acknowledge nods, quizzical looks, or shakes of the head.
- Do not be afraid to be slightly mean. For example, look for what doesn't work and zero in on it. Here are tried and true side-coaching statements:

Sample side-coaching

Is that *it,* clown? (Wait for confused look and hesitant nod.)

That's not very funny is it, clown? (Clown shakes head in agreement.)

We thought you were a world-famous clown! Right?! (Clown nods.)

You know this is an important audition, right? (Clown nods again.)

This is a *family* show! *Shame* on you! (If clown was bawdy.)

Was that the best you can do? (Clown must nod.)

Well, try it again but *better!* (Or faster, cleaner, funnier.)

It was *worse* that time, don't you think? (Make sure the clown agrees.)

What kind of a costume is *that?* Can you fix it? (Let clown alter costume on the spot.)

Well . . . Thanks, clown . . . Now don't call us, we'll call you. (Give clown time to exit.)

Actor advice—dealing with side coaching
- Stay in yes-mode. Do not make circus owner wrong.
- Agree with false statements.
- Repeat responses that evoke audience responses.

- Share your thoughts and emotions as openly as possible.

Discussion
- How did it feel to be picked on?
- How did the clown deal with the circus owner?
- What does it take to stay positive?
- At what point did abject failure become an inspired choice?
- Describe the clown in one word.

VULNERABILITY

When faced with disaster you will either run, hide, deny events, *or* stay in the moment and put your soul on the line. Choose the latter. Doing so demands a high degree of vulnerability. Truly vulnerable clowns are fully committed to yes-mode acting. They acknowledge trials and tribulations. They share the truth of each moment, no matter how uncomfortable it is to share. Acknowledged failure magnifies a clown's essence and is the surest means of solidifying audience connection. True vulnerability connects the heart of the performer with the hearts of the audience. If you are prone to failure and willing to admit it, you will be endeared to your audience forever.

Keep in mind that vulnerability does not mean feeling sorry for yourself. There's nothing less appealing than a performer who wallows in self-pity. Avoid overreaction; many clowns become angry when audience reaction does not meet their expectations. Irate clowns look for scapegoats, deny responsibility for their actions, and shun vulnerability. Adding insult to injury, nobody feels compassion for a brat (especially a brat in a clown nose).

Exercise 3.13: Love You, Hate You
ten minutes
This is an opportunity to access vulnerability through rejection. Every honest clown pays attention to what the audience thinks. Their judgments—acceptance, rejection, or indifference—impacts the choices you make. Raise the stakes by throwing your heart and

soul into this routine. Prepare your puppet show assiduously before bringing it in for performance. Listen to the side coach and react honestly. Do not indicate feelings. Avoid becoming truculent—negativity turns to poison. Repeat reactions that receive audience response.

1. Drop into clown and enter.
2. Perform a puppet show with socks, stuffed animals, or pieces of fruit.
3. Connect with the audience throughout.
4. Finish the performance, bow, and remain center.

Side coaching

Begin coaching after the puppet show is complete. Speak with conviction. Give the clown time to react. Silence is golden—throw a comment out there and wait.

We loved you, clown. (Pause.) You are so talented. (Pause.) How did you get so good? (Pause.) Can you show us the ending where the puppets twirled? (Pause.) Great! Again? Magnificent!

Just kidding clown. (Pause). That was terrible. (Pause). Those puppets stink. (Pause). You stink. (Pause.) Do the middle part where the puppets jump. (Pause). Terrible. No talent. (Pause). Sorry. (Pause). Awful.

No, no, no! Just fooling! (Pause). Really: You are the best puppeteer ever. (Pause). We love you! We love your puppets. (Pause). Bring them out again so we can applaud. (Applause.)

Continue to alternate between loving and hating the clown routine.

Discussion
- When did the clown become vulnerable?
- Was the clown affected by positive comments? Negative comments?
- Discuss the shifts that occurred.

"We love you, clown." "We hate you, clown."

- When was the clown essence most prevalent?
- Describe the clown in one word.

Exercise 3.14: Instant Routines

fifteen minutes

Creating instant routines demands a willingness to flirt with disaster. You must work spontaneously, remaining vigilant for sudden twists of fate. Take off your thinking cap and go with first impulses. Look for opportunities to break expectations.

1. Clown enters and waits for instructions.
2. Side coach throws world-famous clown a secret prop and gives instructions. (Keep all props hidden in a bag).
3. Sample props and instructions:
 - Toy rabbit: *Hello, World-Famous Toy Rabbit Clown! Show us how you feed the bunny invisible ice cubes (spaghetti, cupcakes).*
 - Ten balls: *World Famous Juggler: Keep all these balls in the air.*
 - Hat: . . . *Show us how you fly the hat like a kite.*
 - Cup of water: . . . *Show us how you take a bath.*
 - Kleenex: . . . *Show us your paper airplane trick.*
 - Jump rope: . . . *Show us how you floss your teeth.*

4. World-famous clown performs requested trick immediately. No excuses, no time to think.

Discussion
- When did the new routine take off?
- What was the most inventive aspect of the instant routine?
- How might this be converted into a radiant clown act?
- Describe the new clown essence in one word.

Instant routine: flossing teeth with rope

REPETITION AND MODIFICATION

Exercises 3.1 through 3.14 should be repeated as needed. There are countless ways to modify each exercise. Feel free to combine divergent tasks. For example, in exercise 3.14, Instant Routines: Throw new inspirations and challenges at the clown. Develop new dances. Repeat exercises that are exceptionally demanding. Modify cos-

tumes and props. Incorporate side-coaching to ensure high stakes and vulnerability. During feedback, continue to define the clown in one word.

ADVANCED CLOWNING: NEW DIRECTIONS

Having clarified your clown essence through connection, yes-mode, risk, heightened stakes, and vulnerability, you are well prepared to engage in advanced clowning exercises. Each technique acquired thus far will support ongoing clown experimentation. Advanced exercises continue to test your clown's reflexes, imagination, and positive attitude.

ALTERNATE ESSENCES

A clown that freely shifts from one essence to another is exhilarating. Swinging between extremes fosters actor flexibility and range. Shifts must be precise. Precision requires focus, determination, and practice.

Spotlight: Harpo Marx
Harpo Marx, a brilliant mute clown, constantly shifted between befuddlement and new ideas. Watch him in *Horse Feathers, A Day at the Races,* or *Duck Soup*—three of the Marx Brothers' finest films. He never knew what would happen next until—zap!—a new idea struck him. These inspirations materialized in the moment. Harpo, ever a generous yes-mode clown, shared these revelations with the audience. Then, in the wink of an eye, he leapt fluidly between thoughts, essences, and actions. One moment he was sad. The next moment he was in love. One moment thinking. The next moment honking his horn, pulling out scissors, or diving into a piano. His clown was defined by decisive shifting and quixotic essences.

Exercise 3.15: External Shifts
ten to fifteen minutes

This initiates exploration of opposite aspects of your clown personality. Shifts are spurred by side coaching. Listen to your coach and follow directions.

1. Enter as clown.
2. Follow side-coaching directions:
 Hey clown! Show us your sad clown. What do you do that is sad? (Pause.)
 Happy. What do you do that is happy? (Pause.)
 Sexy. What do you do that is sexy? (Pause.)
 Dumb. What do you do that is dumb? (Pause.)
 Confused. What do you do that is confused? (Pause.)
 Wild. What do you do that is wild? (Pause.)
 Quiet. What do you do that is quiet? (Pause.)

Discussion
- Did the clown stay in yes-mode?
- Was it possible to find alternate essences?
- Describe *all* essences using one word.

Exercise 3.16: Activity Shifts
fifteen minutes
There is no side coaching here. Use a simple prop. Stretch yourself in both directions. Don't mug. Shift cleanly. Share contradictions, conflicts, and struggles with the audience.

Dynamic internal shifts involve extreme opposites such as:

- Quick/slow/quick/slow . . .
- Vulnerable/tough/vulnerable/tough . . .
- Smart/dumb/smart/dumb . . .
- Happy/sad/happy/sad . . .
- Outgoing/shy/outgoing/shy . . .

In other words, if you are a dumb clown be sure to shift toward keen intelligence. If you are sleepy look for a perky opposite. Keep

in mind that shifting cleanly does not necessarily mean shifting quickly—work at whatever tempo best suits your clown.

1. Enter as clown.
2. Engage in a simple activity.
 - Blowing up a paper bag—hopeful. Bag loses air—defeated . . .
 - Picking petals from a flower. She/he loves me, loves me not . . .
 - Working out—feeling strong. Taking a break—exhausted . . .
 - Enter with umbrella—rain: cold. Close umbrella—dry: warm . . .
3. Continue shifting several times.
4. Exit as clown.

Discussion
- Which essence was most powerful? Evocative? Interesting?
- How did the shifts shape the clown?
- Describe *each* essence using one word.

Exercise 3.17: Dance Shifts
ten minutes

Use music with dynamic changes. The opening of Beethoven's Fifth Symphony is a perfect example. If you are inspired, you can make tapes or CDs that fuse different songs into a medley of startling shifts. Shift your dancing style as the music changes.

A note: This exercise also works well when the coach introduces surprise music.

1. Clown enters.
2. Music begins, clown dances.
3. Music shifts, clown shifts.
4. Clown continues to shift with music.
5. Clown exits.

APPLIED CLOWNING

SHARING THE STAGE: DUOS

There is great value in partnering with other clowns. Up until now your solo acts permitted you to dominate the stage. In duo clowning, the stage must be shared. Your attention must constantly shift between activity, partner, and audience. To begin, engage in an activity, then share key moments with the audience. In this way, try to win your watchers over—make them *your* confidants. This will bolster your duo act (especially if you are in conflict with your partner).

There are many ways to partner clowns. Each pairing produces unique results. It's best to begin by combining clowns with contrary personalities. For example, mix a good clown with a bad clown, shy with outgoing, or sexy with prudish.

Spotlight: Laurel and Hardy

The golden age of American vaudeville sported many brilliant entertainment duos. Laurel and Hardy were one of the era's finest comic teams. The two were a study in opposites. One was tall, the other short. One fat, one thin. One smart, one dumb. One fast, one slow. They never got along, but they never stopped trying to sort out their problems. Each conflict demanded heightened listening skills and split-second timing. The joy was in watching them search for ways to resolve intractable conflicts.

Exercise 3.18: Launching a Duo
fifteen minutes

It is best to start from scratch. Scrap your old routines—they were developed for solo clowning and will not necessarily hold water now. Share the stage openly. Do not attempt to direct the act—work collaboratively. Stay in yes-mode by accepting what is happening. This does not imply that you should not fight with your partner. If there is something worth fighting for, bring out the cannons.

1. One clown establishes a simple activity.

2. The second clown enters and messes things up.
3. Both clowns attempt to resolve the problem.

Discussion
- Did the clowns work together or remain at odds?
- Describe the high points of the scene.
- Was there a natural leader or did the clowns share supremacy?
- How might the act be enhanced?

Exercise 3.19: Dance Duos
fifteen minutes

Try these partnering dancing styles. Investigate moments of conflict and resolution. Add appropriate (or inappropriate) music, and rehearse through improvisation.

1. Fred Astaire and Ginger Rogers
2. Ballroom
3. Tango
4. Swing
5. Tap duets
6. Lord of the Dance

Discussion
- Did the clowns' dancing abilities (or lack thereof) enrich the routine?
- Did their lack of knowledge make it work?
- What were the best moments?
- How would you define these clowns in one word?

Exercise 3.20: Improvised Duos
fifteen minutes

Do not rehearse. Agree on a task, put on your noses, and perform. Connect with the audience throughout.

1. Choose an impossible physical task for the duo.

Tango

- Building a skyscraper
- Playing baseball with two full rosters of players, umpires, and fans
- Synchronized swimming
- Log races
- Switching clothes simultaneously

2. Engage in the activity with your partner.
3. Build the activity with a sense of adventure. Embrace failure.
4. Collaborate with your partner to resolve dilemmas.
5. Discover a culminating moment for the act.
6. Take bows and exit.

Discussion
- When did the duo act begin to take shape?
- Was there a natural leader and follower?
- How might this act be improved for future performances?
- Describe each clown in one word.

Exercise 3.21: Synchronicity
thirty minutes—rehearsal
five minutes—performance
Synchronized duo clowning is breathtaking to behold. This is a skill-based act in which both clowns harmonize their movements. Use peripheral vision to watch both your partner and the audience. Select music that cues the action.

Rehearsal
1. Clown partners face each other—three feet apart (start music).
2. Clowns mirror one another. Move slowly, beginning with simple face shifts.
3. Incorporate hands, arms, feet, and legs. Keep movements simple.
4. Develop a routine that can be performed in synch.
5. Practice the routine until you are both confident.
6. Face out (to imaginary audience) and practice.

Performance
1. Enter in synch.
2. Perform routine facing out to the audience.
3. Bow in synch. Exit in synch.

Discussion
- What was striking about this duo performance?
- How have the clowns evolved?
- Do these clowns make a compelling duo?
- Are they a match made in heaven or hell?
- In what ways might the clowns evolve from here?

IN CONCLUSION

Clowning offers endless possibilities for risky situations and inspired resolutions. As you acquire new skills, clarify your essence, discover and modify routines, improve through side-coaching, connect with the audience, and develop duo routines, your clowning technique will blossom. Once you are bitten by the clown bug it is only natural to speculate about dancing to divergent music, incorporating a distinctive prop, and sharpening routines. Speculation leads to trial and error. Error leads to brilliance. The best way, the *only* way, to scratch the clowning itch is to slip on the red nose, obey the clown rules, and give inspiration a whirl. May your clown live long and prosper.

HALF-FACE MASKS

OVERVIEW

Lunacy n. *Extreme folly or eccentricity.*
—The New Oxford American Dictionary, *2001*

Half-face masks are lunatic in nature. They beget eccentric characters that demand a high degree of energy, precision, and commitment. The work is based on instant transformation—a technique, as the name implies, that moves quickly and decisively toward character inhabitation. The work reinforces key acting techniques used for full-face masks, bagging, and clowning—including physical, vocal, and psychological transformation, character building, precision shifting, audience connection, and creative play. You will create dozens of original Hu-Masks that can be integrated into set scenes, wild improvisations, or the creation of original commedia-style plays.

TERMINOLOGY

A *half-face mask* is the object that covers part of your face.
A *Hu-Mask* is the character you become—a human in a mask.
Instant transformation refers to immediate changes in your thoughts, actions, voice, and body when the mask becomes a Hu-Mask.
Dropping in refers to the moment you put on the mask and begin the process of transformation.

Dropping out refers to the moment you take off the mask and return to your self.

Neutral-ready is your state of alert relaxation prior to dropping in and after dropping out of mask.

The *standing line* is where you stand before dropping into mask—three feet from mirror.

Statues capture the distilled, fluid essence of a Hu-Mask.

Shifting denotes a change in your acting. These are physical, vocal, physiological, or emotional in nature. Shifts also alter the tempo and intensity of a scene.

Commedia delle'Arte is a highly physical theatrical style that uses half-face masks.

Stock is a standard set of characters used in commedia plays.

Lazzi are repeated jokes, slapstick, or pratfalls.

Busking refers to actors who are building an audience.

An *objective* is what the Hu-Mask wants.

An *action* is the way the Hu-Mask attempts to fulfill the objective.

An *activity* is what the Hu-Mask does (i.e., knit, sew, crumple paper, skip, sing, etc.).

COMMEDIA CONNECTION

Half-face masks are closely related to a theatrical genre known as Commedia delle'Arte. It is important to clarify that the focus of our work is half-masks, not commedia. We are interested in using half-masks to acquire new acting skills such as spontaneous improvisation, physical and vocal agility, multiple role playing, and the development of signature lazzi (repeated jokes or stunts). All of these skills were used by commedia actors. Separating half-face masks from commedia is like trying to swim without water; the masks inform the genre and vice versa. Whether you understand the basic concepts of commedia or not, those concepts are in full force when you act in half-face masks. Therefore, it makes sense to have a basic grasp of fundamental commedia principles. It is fascinating to discover how your creative efforts are linked through time to the antics of original commedia players.

A Brief Commedia Overview

Commedia originated in Europe during the late sixteenth century and flourished during the eighteenth and mid-nineteenth centuries. Seminal commedia troupes traveled from town to town performing wherever local laws allowed. Performances were staged in outdoor courtyards and marketplaces. The set was a raised wooden platform. A painted curtain was hung upstage for entrances and exits. Actors changed clothes and masks behind the curtain.

Each commedia followed a simple story line: for example, young lovers foiled by overprotective parents, a magician on a quest for magic potions, or rival captains pursuing young wenches. The action was extremely physical—laced with bawdy jokes and acrobatic pratfalls. Audience response—laughter, groans, applause, or flying fruit—prompted improvised bits of business. Over time, actors developed specific bits of business for each stock character. Audiences came to expect these jokes and stunts—lazzi—and identified the characters by their specific tricks.

Commedia's roving theatre companies featured stock characters such as Arlecchino, the wily servant; Capitano, the strong captain; and Pantalone, the mean old father. Servants and lower-status characters wore masks. Royalty and higher-status characters remained unmasked. Each character moved, spoke, and behaved in specific, predetermined ways. Many of the lower-status characters were modeled on animals. Actors sported half-face masks, costumes, and props; thus, stock characters were recognizable from the moment they entered. For example, Il Dottore, the quack doctor, had an oversized nose (in which he hid his medicines), wore dark clothing and a black hat, walked slowly, and lectured anyone who was dumb enough to listen. Arlechino was based on a monkey, used a black mask with small eyes and warts, wore a multi-colored costume, and carried a slapstick to whack enemy characters during heated arguments.

Commedia has influenced myriad theatrical genres over the past several centuries, from Shakespearean and Restoration comedy, to

high farce, street theater, sitcoms, and stand-up. Each of these genres also features stock characters. In a sitcom, for example, the same characters appear week after week—only the situations change. The more extreme the situation becomes, the higher the potential for rollicking fun. Once again, repeated jokes generate much of the laughter. Thus, half-face masking, infused with the wild abandon of commedia, strengthens your ability to act in divergent comic styles.

COPY CAT, DIRTY RAT

To create, in the real sense, means to discover and show new things. But what novelty is there in the stilted mannerisms and clichés of the fettered actor?
—*Michael Chekov,* To the Actor

The original European commedia players lived hundreds of years ago. Their work was informed by the social, political, and economic issues of their age. We live and act in an entirely different period of time. What can we glean from these brethren artists? How do their theatrical innovations continue to inform ours? There are several areas of note:

- They capitalized on the verbal and physical power of half-face masks.
- Companies presented multiple characters by wearing myriad masks.
- Lazzi were tested and refined from performance to performance.
- Political barbs were veiled by jokes, stories, and caricatures.
- The plays featured simple sets, costumes, and props.
- Audiences knew the stock characters and came to expect familiar stories and jokes.
- Actors interacted directly with audiences.
- Performances were continuously altered through improvisation.

You will experience the veracity of these approaches when cavorting in half-face masks. But do not attempt to imitate the perfor-

mance patterns of original commedia actors. Lacking video footage, we do not know precisely how they moved or spoke (although there are written accounts and a rich oral tradition describing improvised lazzi). While it is true that great art is often stolen, commedia imitation is of limited value. Repeating gestures, winks, and bits will not improve your acting in any measurable way. In fact, repetition damages creative instincts. In this genre, your best efforts will arise from *original* inspiration. Therefore, remain cognizant of commedia's contributions to half-face masking but, at the same time, remain committed to developing your own characters, plots, and lazzi.

TOP OR BOTTOM?

Most half-face masks cover either the upper half of your face (top of forehead to below the nose) or the lower half (from nose to chin). Some half-face masks cover the right or left side of the face (Phantom-of-the-Opera style). Clowning utilizes a minimalist partial-face mask. Traditional commedia half-face masks cover the upper portion of the face. It is interesting to note that slight alterations to a mask's forehead, cheeks, or nose powerfully affect the nature of the mask.

This chapter focuses on upper half-face masks for the following reasons:

- The masks are relatively simple to build.
- Mouths are uncovered, prompting vocalization.
- They do not slip during frenetic moments.
- They merge well with wigs and hats.
- There is a direct correlation to archetypal commedia masks.

PRE-MASK FOUNDATION EXERCISES

We begin by creating an unmasked set of stock characters. These will, necessarily, be drawn from your life experience: family members, lovers, acquaintances, or people you have observed in the course of daily life.

A sampling of modern stock characters

Lifeguards	Druggies
Used-car salesmen/women	Soccer moms
Teenie boppers	Dumb blondes
Bank tellers	Sleazy politicians
Rock stars	Jocks
Dog trainers	Surfer dudes and dudettes
Drama coaches	Band conductors
High school English teachers	Coffee sellers
Military leaders	Femme fatales
Beggars	Sports fans
News broadcasters	Cat owners
Bratty kids	Bird watchers

We *know* these people. Some we like, some we love, some we endure, others we despise. We identify with specific types because we *were* that character or *knew* that character, at one point in time. Traditional stock commedia characters are closely related to our modern stock. For example, the pomposity of Il Dottore can be equated to contemporary doctors, politicians, or military leaders. Our jocks and rock stars are fueled by the same physical strength and inflated ego as Capitano. Hopped-up coffee drinkers are modern-day zanies. The more things change, the more they stay the same. Rest assured, your characters are as valid as those created three hundred years ago.

Exercise 4.1: Modern Stock
Two minutes
Each actor chooses three modern commedia types (use original inspiration rather than the list above). Think of a simple activity for each character. Avoid generalized attributes. Work for physical and vocal truth. Play characters, not caricatures. Unleash your energy, imagination, and spontaneity. Stay in the moment.

1. Enter in neutral-ready.

2. Drop into first character and engage in activity *(thirty seconds)*.
3. Shift into second character and activity *(thirty seconds)*.
4. Shift into third character and activity *(thirty seconds)*.
5. Exit in neutral-ready.

Discussion
- Were the characters believable?
- Did you notice physical and vocal variation?
- Were the shifts clean?

Repeat this exercise several times, to clarify old characters and/or introduce new ones.

Exercise 4.2: Swapping Faces
ten minutes

With practice, non-masked instant transformations occur with increased rapidity and ease. As the pace increases, creative impulses flash by in the blink of an eye. You will sense these impulses before you can conjure or contemplate them. Absence of thought is a good indication of proper engagement. If you begin to think your way through the work, reconnect with initial impulses. Focus on those seminal creative sparks; an enhanced ability to act impulsively and transform quickly paves the way for half-face masking.

Instant transformation begins with the face. Actors are divided into two straight lines, at opposite ends of the studio, facing each other. Actors are paired off and designated X or Z.

1. Stand in neutral-ready, gazing easily across the studio at your partner.
2. At coach's signal (hand clap) X's adopt a face.
3. At coach's signal both lines walk toward each other.
4. As lines pass, Z adopts X's face.
5. Z and X maintain the same face to opposite sides of studio.
6. Turn and look at your partner when you reach the other side.

7. At coach's signal, relax your face and drop back to neutral-ready.

During the next rotation, Z's spontaneously create a new face. The exercise is repeated with Z as leader and X as follower.

Switch partners and continue to explore swapping faces.

Coaching notes
- Watch carefully. Allow time for actors to complete each phase of the exercise.
- Clap loudly and decisively.

Discussion
- Were you able to drop into a new face?
- How clean were the swaps?
- Did your partner accurately mirror your face?

A note: Exercises 4.3 through 4.6 build on this format. Follow your instincts when creating new characters. Work for specificity when grafting your partner's choices.

Exercise 4.3: Face and Body
ten minutes

1. Begin in neutral-ready.
2. X's find a new face, then add physical transformation.
3. Lines walk toward each other.
4. Z's graft face and body to other side of room.

Exercise 4.4: Walk the Walk
ten minutes

1. Z's begin with face and body transformation.
2. Z's incorporate a clearly delineated walk for each new character.

3. X's graft face, body, and walk.

Exercise 4.5: Talk the Talk
ten minutes

1. X's begin with face and body transformation.
2. X's add vocalizations when walking to the center of the studio.
3. Z's adopt face, body, walk, and voice.

Exercise 4.6: Back to the Mirror
ten minutes

1. After switching places, walk back to the center of the studio so that you are facing your partner.
2. Observe your partner. Check that each aspect of the transformation is reflected.

Discussion for Exercises 4.3, 4.4, 4.5, and 4.6
- Were the elements added with specificity?
- Was each element copied accurately?
- Were you clearly reflected when you looked back at your partner?
- How quickly and thoroughly were you able to transform?

SETTING UP FOR HALF-FACE MASKING

CLOTHING

- Black tights and leotards as a costume base. Avoid lettered t-shirts.
- Black socks and shoes.

WIGS

- Collection of different lengths, colors, and styles.

COSTUMES

- Half-face masks are attracted to bright colors and gaudy patterns.
- Raid the costume shop and local thrift stores.
- Collect dresses, shirts, jackets, scarves, shoes, socks, tights, pants, shorts, skirts, gloves, ties, bows, belts, and hats.
- Find assorted sizes.
- Avoid predicting how the costumes will be used.

PROPS

- Half-face masks enjoy playing with anomalous knick-knacks.
- Raid the prop shop and local thrift shops.
- Collect bizarre, broken, or unidentifiable items.
- Avoid predicting how the props will be used.

STUDIO SET-UP

- Wall of mirrors on one side of the studio.
- Table to hold masks.
- Taped standing line—three feet from mirror.
- Table for wigs and hats (used for exercise 4.11 and after).
- Clothing strewn around the studio (used for exercise 4.12 and after).
- Table for props (used for exercise 4.13 and after).

Be willing to make a mess. Half-face Hu-Masks come to life when costumes, wigs, and props are strewn throughout the studio. A wild space supports spontaneous choices and free play.

BUILDING HALF-FACE MASKS

You will want to build at least a dozen half-face masks in order to have a variety of choices for each masking rotation. Once you have

established a system for construction, you can complete several masks at a time. Design and build a variety of shapes and colors. *Please see appendix for half-face mask building instructions using Celluclay.*

CORE EXERCISES: ACTING IN HALF-FACE MASKS

Instant adj. *Happening or coming immediately. Becoming a specified thing very suddenly. Prepared quickly and with little effort.*
—The New Oxford American Dictionary, *2001*

Half-face masking is based on instant transformation—a technique, as its name implies, that promotes immediate change. You must tap instinctive responses to the masks, then act accordingly. Whereas full-face masks use pre-transformation meditation, and bag masks demand rehearsed scripts, these masks spark to life with little or no preparation.

The speed of the work negates conscious control over situations, actions, and objectives. In fact, overanalysis restricts creative instincts.

A note: In order to prevent physical and vocal strain, engage in a thorough warm-up before dropping into mask. Designate yourself an active watcher if you are sick or have a debilitating physical injury. There is much to learn by observing your peers at work.

RULES OF THE ROAD

1. No hitting other Hu-Masks, running into walls, or jumping from dangerous heights.
2. Actors must drop out of mask when ordered to do so. This command may come from the coach or other actors in the space.

Exercise 4.7: Five Quick Stances
two minutes per mask

Working quickly prompts intuitive responses. There is no time allotted for meditation. Drop immediately into Hu-Mask. Avoid overthinking. Trust initial responses.

1. Actors choose masks quickly.
2. Step to the standing line, facing away from the mirror in neutral-ready.
3. Put on mask. Adjust straps and hair.
4. Turn to mirror.
5. Drop immediately into mask. Adjust:
 - Mouth
 - Hair
 - Eyes
 - Tilt of head
6. Clarify stance.
7. Shift into five stances. (Coach claps and calls out stance numbers: 1—2—3—4—5.)
8. Turn, drop out of mask, and return to neutral-ready.
9. Journal quickly.

Repeat this exercise with five different masks.

After completing each rotation, take a minute (an actual minute) to journal about discoveries. Write quickly. Elaborate metaphors subdue the energy you need to continue transforming. Return to your journal later in the day and fill in the blanks.

Discussion
 - Were you able to transform in each mask?
 - Which mask yielded the deepest transformation?

A note: Keep discussions to a minimum. Excessive chatter diminishes the learning curve. Quickly acknowledge what is working, then move to a new mask.

Exercise 4.8: Walk This Way
fifteen minutes per mask

Stances segue to walks. The moment you feel an impulse, move. If your specificity begins to wane, return to the mirror and check back in. Transition to and from the mirror as needed.

1. Use your first mask from exercise 4.7.
2. Move to standing line and drop into mask quickly.
3. Reestablish first stance in the mirror. (No coaching necessary.)
4. Walk away from mirror.
5. Practice stance and walk.
6. Return to mirror. Perfect walk and stance.
7. Repeat with stance two, three, four, and five. Find new walks for each Hu-Mask.
8. Turn and drop out of mask.

Repeat this exercise with two other masks from exercise 4.7.

Discussion
- Did you find a walk that served the mask?
- Were you able to shift into and away from the mirror?
- How did your Hu-Mask change as your focus shifted?

Exercise 4.9: Fluid Statues and Gestures
ten minutes per mask
You can deepen the essence of your mask characters by creating fluid statues, then adding gestures (see chapter one, Full-Face Masks, exercises 1.11 and 1.12). Think of each statue as a fulfillment of the character's essence. You are a master sculptor, using your own body to flesh out the nature of your Hu-Mask creation. Keep the work alive by breathing deeply. Retain a sense of ease and breathe deeply when looking into the mirror; freezing saps energy.

1. Begin, once again, with your first mask from exercise 4.3/ 4.4.
2. Move quickly to the standing line. Put on the mask.

3. Turn to mirror and drop into Hu-Mask, as above.
4. Reconnect with walk and stance.
5. Return to mirror.
 - Drop into statue one. Add a gesture.
 - Drop into statue two. Add a gesture.
 - Drop into statue three. Add a gesture.
6. Turn away from mirror and drop out of mask.

Repeat this exercise quickly with two additional masks you have used.

Coaching note:
Call for a new statue by number, then clap loudly.

Discussion
- Which statue captured the mask's essence?
- Discuss your ability to combine gestures and statues.
- Were you able to remain fluid throughout?

Statues with gestures in the mirror

Exercise 4.10: Finding Voice

ten minutes per mask

Unlike full-face masks, half-face masks are verbal in nature. Whether you are improvising or following a predetermined plot line, these Hu-Masks will mumble, blabber, scream, sing, and chant a blue streak. It is difficult to predict exactly how a half-face Hu-Mask will vocalize until the transformation is underway. Sometimes they speak in foreign tongues. Sometimes they are steeped in ancient languages. You may find yourself articulating coherently or spewing nonsensical gibberish.

A note: Whatever direction your mask takes, be prepared to discover new vocabularies and ways of speaking. Usually, if you are prepared to vocalize, the mask will speak. Go where your instincts lead. Continue experimenting with sounds until the moment you drop out of mask.

1. Choose a mask you have used.
2. Move to standing line. Put on mask.
3. Turn to mirror and drop into mask.
4. Vocalize as soon as transformation begins.
5. Vocalize as you deepen walk and stance.
6. Return to mirror and statue/gesture with vocalizations.
7. Turn away from mirror and vocalize. Drop out of mask.

Repeat with two additional masks you have used and two new masks.

Discussion

- Did vocalizations arise naturally?
- How would you describe the Hu-Mask's voice?
- What verbal surprises did you encounter?

Exercise 4.11: Wigs and Hats

fifteen minutes per mask

Adding wigs and hats can deepen a Hu-Mask or alter it altogether. Avoid adding too many elements at once. For example, add the wig first. Experiment with the wig until you can integrate it into the

evolving character. Then, add a hat—if the Hu-Mask needs one. If the hat doesn't work, toss it off. Try a new hat. If several hats do not fit, stop trying; your Hu-Mask doesn't wear a hat. Keep the wig and proceed with the exercise. Work quickly, as always.

Set-up
A table with various wigs and hats.

1. Choose a mask you have worn.
2. Drop into mask.
3. Find statues, gestures, walk, and voice.
4. Select a wig.
5. Integrate Hu-Mask and wig, using the mirror.
6. Add a hat.
7. Check in with the mirror to see if the hat works.
8. Practice walks and statues with new elements into and away from mirror.
9. Drop out of mask.

Add wigs and hats for several additional masks.

Discussion
- Were you able to reestablish the Hu-Mask?
- How did the wig alter your visage?
- Did you find a hat that worked? Describe the process of selection.
- Describe how these new elements affected the Hu-Mask.

Exercise 4.12: All Dressed Up
twenty minutes per mask
Half-face Hu-Masks know exactly what to wear. They will lead you directly to clothing that "fits." If you happen to choose a garment that does not work, fling it aside and try something else. As always, follow your instincts and avoid logical choices.

Set-up

Create a roaring mess. Scatter clothes, wigs, and hats in all directions.

1. Choose a mask you have worn.
2. Drop into mask.
3. Add wig and hat.
4. Statue, gesture, walk, and vocalize.
5. Walk away from mirror.
6. Allow Hu-Mask to try things on and choose clothing.
7. Return to mirror and statue in clothing.
8. Walk away and add a new garment if needed.
9. Return to mirror and statue again.
10. Turn and drop out of mask.

Repeat this exercise with two additional masks you have used.

Discussion

- Were you led to particular costume pieces?
- Discuss how clothing changed the mask.
- Surprises?
- Were there specific garments the Hu-Mask wanted but could not find?

Exercise 4.13: Propping Up

You now know that half-face Hu-Masks are prone to unpredictable sparks of physical zaniness. It is possible to harness this energy by engaging in specific activities. Hu-Masks, like characters in plays, are defined by what they do. If you don't have a specific task in mind, you will become an inconsequential blur of sound and motion. It is difficult to make sense of a Hu-Mask that simply races around the studio, babbling incoherently. Furthermore, it is tricky, if not impossible, to incorporate uncontrolled wildness into scenes or improvisations.

A good prop will suggest a definitive means of engaging in an activity. Out of the blue, there is something to do. The ball can be

bounced. The flower can be planted. The stick can be broken. The rope can be coiled. Half-face Hu-Masks are endlessly fascinated by props and activities. In time, a Hu-Mask will identify with a specific prop and cannot be parted from it.

When you begin, permit the Hu-Mask to select a prop and subsequent activity. Remain open to irrational choices.

Set-up
A prop table with assorted props and knick-knacks.

1. Select a mask you have worn.
2. Drop into mask.
3. Add wig, hat, and clothing,
4. Reconnect with stance, gesture, walk, and voice.
5. Go to prop table. Select a prop.
6. Engage in an activity with the prop.
7. Return to mirror with prop.
8. Find statue essence with prop and activity.

Practice this exercise with three masks you have used.

Discussion
- What prop did the Hu-Mask choose? Why?
- What activity was launched? How did the activity arise?
- Define the Hu-Mask's relationship with the prop.

Exercise 4.14: Reviewing Hu-Masks
two minute per mask—ten minutes total
Before moving to scene work, take a moment to review the half-face Hu-Masks you have created thus far.

A note: This exercise is reminiscent of multiple-character bagging (chapter three, Bag Masks). The key is to shift cleanly between masks.

1. Line up four masks you have fully inhabited.

Hu-Mask broken ukulele entertainer-in-a-box

2. Place wigs, hats, costumes, and props on a chair next to each mask.
3. Drop into one mask at a time.
4. Add elements and engage in activity.
5. Drop out of mask. Shift to new mask. Repeat.
6. Return to neutral-ready.

Discussion
- Were you able to fully inhabit each Hu-Mask?
- Which Hu-Mask moved you most strongly?
- How might these masks interact in a scene?

Exercise 4.15: In and Out of Half-Face Masks
fifteen minutes per mask

This will aid you in using masked discoveries for non-masked assignations. Choose a mask that yields a deep transformation and

is inherently active. Trust the clarity of your Hu-Mask choices. Work quickly between masked and unmasked actions. Maintain masked energy when unmasked.

1. Drop in and reconnect with Hu-Mask.
2. Practice Hu-Mask activity for several minutes.
3. Quickly take off the mask and continue—in character—with activity.
4. Quickly put the Hu-Mask back on and continue with activity.
5. Drop out of mask, return to neutral-ready, and journal.

Discussion
- Were you able to reconnect with the Hu-Mask?
- What occurred when you removed the mask?
- Could you sustain transformation out of mask?

Repeat this exercise with several additional masks.

CORE EXERCISES: DYNAMIC DUOS

Half-face Hu-Masks have a childlike love of games. They are naturally inclined to play with other masks. A few Hu-Masks, like shy children, prefer to play alone. But even the most reticent Hu-Masks can usually be induced to play. All you need is an appealing stream of interactive options. Once you begin partnering with other Hu-Masks, you must remain open to impulses and ideas. Develop ideas collaboratively; neither you nor your partner should be sole director of the scene.

Exercise 4.16: Sharing Activities
Choose a mask you know. Then, before dropping into mask, select a partner. Preset wigs, hats, and props. Work side by side, synchronizing each step. Work collaboratively without trying to control the scene.

1. Partners drop into mask.

2. Partners establish stances, walks, voices, wigs, and hats.
3. Hu-Masks pick up props.
4. Hu-Mask A demonstrates prop activity. Hu-Mask B joins in.
5. Hu Mask B demonstrates prop activity. Hu-Mask A join in.
6. Perform statues in mirror.
7. Drop out of masks.

Discussion

- Were you able to collaborate?
- What discoveries did you make about relationship?
- Did your partner's prop and activity hold your interest?
- Discuss how the scene improved.

Upon completion of this exercise, each pair of Hu-Masks performs a shared activity for the class.

Exercise 4.17: Song Birds

Use the same masks as in exercise 4.16.

1. Partners drop into mask.
2. Hu-Masks establish stance, walks, voice, wigs, hats, and prop activities.
3. Hu-Mask A sings to Hu-Mask B.
4. Hu-Masks sing together.
5. Then Hu-Mask B sings to Hu-Mask A.
6. Hu-Masks sing together.
7. Drop out of masks.

Discussion

- Did you enjoy singing? Listening? Joining in?
- What type of musical duet was created?
- Were you able to make music together?

Practice this exercise with three pairs of masks you have used. One set of duo songs are performed for the class.

Literal song bird duo

Exercise 4.18: Talk, Talk, Talk

Early scene building can be activated by unrestricted talking. As you now know, half-face masks are rarely at a loss for words. Start with a mask you have inhabited. Choose general discussion topics before beginning. Stick with topics that will hold the Hu-Masks' attention. Do not attempt to script the scene word for word.

1. Partners drop into mask.
2. Develop the dialogue improvisationally. Follow your verbal inclinations.
3. Allow the conversation to heat up by raising the stakes.
4. Conclude the conversation.
5. Drop out of mask.

Discussion
- Did words flow freely?
- Did one Hu-Mask tend to dominate the conversation?
- Were you inclined to engage in activities while talking?
- Did you develop an interesting script?

Exercise 4.19: Conflict

Predetermine a situation that brings you and your partner's Hu-Masks into conflict. You must agree on an appropriate situation for the Hu-Masks you are using. Each of you must strive to overcome difficulties and achieve objectives. Keep the situation simple, for example:

- Competing in tag, leapfrog, or hide and go seek.
- Stealing partner's clothes, props, or hat.
- Dressing unwilling partner for an important date.
- Teaching tone-deaf partner a new song.

1. Drop into mask, wig, hat, and costume.
2. Practice statues, walks, activities, and songs.
3. Find your partner and initiate situation conflict.
4. Work to achieve your objective.
5. Build the scene to a climax.
6. Drop out of mask.

Discussion
- Did you believe in the situation?
- Did you believe your partner?
- How did you manage to build the scene?
- Describe the culmination of competition.

Repeat exercises 4.7 through 4.19, time permitting. Use new masks for each rotation.

ADVANCED EXERCISES: THE GREAT OUTDOORS

FRESH AIR AT LAST

Half-face Hu-Masks love to cavort outside. Beyond the studio doors, a wondrous sense of freedom awaits. Sunlight, wind, foreign sounds, and smells stimulate your senses. Fresh impulses course through your veins. Unmasked people stand nearby watching and wondering. After cavorting exclusively in the studio, this abrupt environmental shift can be awe-inspiring. Be patient. Explore the expanded universe piece by piece. Connect with one impulse at a time. And stay away from moving cars.

Exercise 4.20: Goodbye Studio
twenty minutes

For your first venture outside, select a mask you know well. It is best to work in pairs and stick close together. Avoid the temptation (for the moment) of accosting unmasked spectators. Focus on interacting with your partner.

1. Drop into mask in the studio.
2. Reestablish costume, wig, and hat.
3. Reconnect with your primary props.
4. Establish activity with your partner.
5. Walk, skip, or hop outside with your partner.
6. Take a few minutes to adjust to the environment.
7. Reestablish your duo activity.
8. Experiment with activity outside.
9. Return to the studio.
10. Statue in mirror with partner.
11. Drop out of mask.

Coaching notes
- Tell the Hu-Masks when to go outside.
- Open studio doors for their escape.
- Watch carefully over Hu-Masks while they are outside.

- Call Hu-Masks back to the studio (be prepared to round them up).
- Open studio doors for reentry.

Discussion
- How did the open air affect your Hu-Mask?
- What surprises did you encounter?
- How did the environment influence activities?
- If spectators were present, how did they affect you?

Repeat this exercise with two or three additional masks.

BUILDING A CROWD

> *The actor who has the audience eating out of the palm of his hand is like the virtuoso violinist who no longer has to watch his fingers as he plays, nor even keep an eye on the bow. He feels the notes as they leave the violin, and listens to them as they float back.*
> —*Dario Fo*, The Tricks of the Trade

Upon their arrival in a new town, seminal European commedia troupes donned their masks and ventured out in search of an audience. These activities—called busking—included music, tumbling, and short improvisations. The actors were professional buskers; without an audience the show could not go on. They refined their lazzi by trial and error, as a matter of survival—just as you are learning now. In the following exercise, your sole objective is to interest and gather as many spectators as possible. Intrigue them. Hook them. Rope them in.

Busking Rules

1. Do not announce your intention to busk. Catch your audience by surprise—this keeps them on their toes. It also gives you an honest opportunity to win them over.

2. Be persistent in your attempts to build a crowd. Quitters never win.
3. Respect the wishes of those who steadfastly refuse interaction (nobody wins if you get punched in the mask).

If you are musical, your primary attempts at building a crowd will revolve around song. Once you are singing, for example, you can determine if this is your best means of attracting attention. Conclusions can only be reached through trial and error. Keep in mind that "normal" (non-masked) watchers will be surprised by your presence and actions. Some will stay to play. Others will be freaked out and attempt to leave the area as quickly and inconspicuously as possible. You will have to make a split-second decision: Let them go or attempt to bring them back into the fold.

Exercise 4.21: Busking
thirty minutes

Preplanning
- You'll need a fresh supply of non-masked people. Find an open area near the studio with a free flow of passersby—courtyards, cafes, or pedestrian thoroughfares. Bridges work well—people must cross them to get to the other side. If you station yourself at one end, you will not have to find a crowd—the crowd will find you.
- Designate a general staging area nearby. This can be a courtyard or grassy field.

1. Drop into masks in studio.
2. Reestablish costumes, wigs, and hats.
3. Practice gesture statues with vocalizations.
4. Reconnect with your primary props and activities.
5. Maintain Hu-Mask as you leave the studio.
6. Seek unmasked spectators and entertain them.
7. See how long you can hold their interest.

8. Improvise freely as you build an audience.
9. Return to studio and statue in mirror.
10. Drop out of mask.

Discussion
- What did you do to build the crowd?
- How long were you able to hold their attention?
- Which activities worked best?
- Were there any surprise reactions?

Repeat this exercise on three different days with three different masks.

Exercise 4.22: Lazzi
Now that you have busked a crowd, what do you *do?* Your audience is standing there looking at you quizzically. Something has to hap-

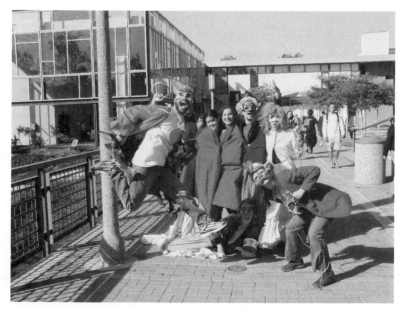

Busking on a bridge

pen . . . soon! This is a golden opportunity to test your ability to entertain a crowd. You do this by engaging in lazzi—your trademark entertainment. These routines can take many forms, including jokes, slapstick, pratfalls, acrobatics, songs, dances, and verbal or physical tricks.

Sample spur-of-the-moment lazzi:
- Dancing with the audience.
- Sharing the audience's lunch, snacks, or gum.
- Juggling badly with audience objects.
- Singing romantic songs to specific audience members.
- Performing instantaneous magic tricks with found props.
- Cart wheeling madly between the spectators.
- Telling obnoxious knock-knock jokes
- Teaching the audience to sing a song with you.
- Checking onlookers' mouths for cavities and "filling" them with pieces of gum.

Notice that these lazzi are interactive. If you can force yourself to play with the audience, you will enjoy better results. At least, if you are not inherently amusing, your audience will have to pay attention (or risk losing their food).

1. Choose a mask that yields an expressive Hu-Mask.
2. Drop into mask, costume, wig, hat, costume, and prop in studio.
3. Practice your lazzi in the studio.
4. Return outside.
5. Busk an audience.
6. Test lazzi—one at a time—and listen for audience response.
7. Repeat physical or verbal moments that reap laughter, groans, or gasps.
8. Continue to repeat moments until they have run their course.
9. Bow and exit.

10. Return to the studio.

Discussion
- What moments worked best?
- Did repetition build responses? When did it peak?
- How did this exercise further define your Hu-Mask entertainer?

Continue to explore new masks and lazzi, as appropriate.

APPLIED HALF-FACE MASKING

CREATING AN ORIGINAL COMMEDIA

Your ensemble is now positioned to create a short play using the Hu-Masks explored in previous exercises. Developing a new piece of theater synthesizes several elements: modern stock characters, instant transformation, working in pairs, busking, and individual lazzi. Rather than following a set script, the next series of exercises uses original inspirations as source material.

Exercise 4.23: Taking Stock
fifty-minute studio discussion
As a launching point, take stock of your stock:

1. List each Hu-Mask created by the ensemble
 | Name | Occupation |
 | Lazzi | Age |
 | Objectives | Activities |
 | Gender | Obstacles |
 | Relationships | |
2. Discuss each Hu-Mask individually. Which ones are usable in the commedia?
3. What is the potential cast of characters?
4. Each actor selects a primary Hu-Mask, and two secondary Hu-Masks.

5. Discuss potential plots. Keep the story simple. Infuse the play with strong objectives and obstacles.

Sample Plot A

Two lovers cannot get together because their mean parents do not approve. They cannot find time alone. Their friends help to bring them together by outsmarting the parents. They live happily ever after and the parents get a divorce.

Sample Plot B

Everyone in town is stupid. A zany idiot searches for a magical smartness potion. The stupid citizens drink the potion and immediately become smart. They attempt to out-think each other. The zany idiot (who never drank the potion) is elected mayor.

As your play takes shape, the relative importance of each Hu-Mask will change. A secondary character may take on a primary role, or vice versa. For now, let each character's relevance rise or fall in accordance with the evolving needs of the play.

Exercise 4.24: Solo Entertainments—Special Skills

Actors perform their primary Hu-Mask for the ensemble. These are solo performances. Once the entire group has performed, solidify a basic cast of characters. Keep in mind that there is no right or wrong combination of Hu-Masks. Every ensemble has a different chemistry. It is unlikely that you will have the classic commedia grouping: Lovers, old men, servants, heroes, magicians, and villains. But even if you wind up with sixteen zanies, the ensemble can forge an intriguing plot. At this formative stage, no one knows (or should know) precisely how the commedia will evolve. Therefore, do not attempt to make final decisions. Hu-Masks will be cut or added later, in service to the play.

A note: If you have a special skill—playing an instrument, gymnastics, blowing bubbles, tying knots, juggling, jumping rope, throwing Frisbees, etc.—this is a golden opportunity to merge your talent with a Hu-Mask. You can bring your talent to bear in the commedia.

1. Drop into primary mask, costume, wig, and hat.
2. Engage in central entertainment with props, as needed.
3. Listen for audience response.
4. Explore potential lazzi.
5. Bow and exit.

Discussion

- How might each Hu-Mask function in the burgeoning commedia?
- What characters are destined to interact?
- Discuss emerging plot possibilities.

Exercise 4.25: Choosing Scenes

twenty minutes

Prompted by ensemble discussions, divide Hu-Masks into pairs for potential scenes. Each Hu-Mask must have an explicit objective in the scene. Build conflict by adding obstacles for both Hu-Masks. Struggle to overcome obstacles and achieve objective.

Sample Scene: "Hunt for Magical Butterfly"

- Hu-Masks are competing to capture the most magical butterfly in the world.
- Simple obstacles that are discovered throughout the scene: Butterfly nets have holes. Butterflies are fast. Hu-Masks are clumsy. It starts to rain.
- The action builds in intensity as Hu-Masks walk, skip, then run through the studio catching and losing butterflies.
- Finally, the magical butterfly is caught.

Pre-mask Scene Sketching

- Sit with you partner and collaboratively discuss your scene.
- Articulate clear objectives for each Hu-Mask.
- Add obstacles that make objectives difficult to attain.
- Identify a beginning, middle, and end for the scene.
- Avoid memorizing specific dialogue.

After you have sketched your scene:

1. Drop into mask, costume, wig, hat, prop.
2. Establish primary activity and voice.
3. Statue in mirror for one minute.
4. Meet your partner.
5. Practice the scene.
6. Return to mirror and statue.
7. Repeat scene.
8. Mirror and statue.
9. Repeat scene.
10. Drop out of mask.

Discussion
- Were you able to follow the basic premise of the scene?
- How did the scene change each time it was repeated?
- Were there particularly intriguing wrinkles?
- How would you continue to enhance the action?

Exercise 4.26: New Hu-Masks—Adding Spontaneity
fifteen minutes

Use the same scene as exercise 4.25. Choose a third Hu-Mask (and third actor) to enter into the scene. This character must join forces with one of the first two Hu-Masks. It is critical to *listen*—otherwise, the three-mask scene will become mayhem.

1. Drop into mask, costume, wig, hat, prop.
2. Establish primary activity and voice.
3. Statue in mirror for one minute.
4. Meet your partner.
5. Perform duo scene for the ensemble.
6. Mirror and statue quickly.
7. Repeat the scene. Add surprise Hu-Mask into the scene.
8. Allow new scene to develop spontaneously.

9. Build scene to a climax.
10. Conclude scene and drop out of mask.

Discussion
- How did the additional Hu-Mask alter the flow of action?
- Were you able to listen and incorporate new ideas spontaneously?
- How might you modify the scene from here?

Repeat this exercise several times with different combinations of Hu-Masks.

Exercise 4.27: Scripted Monologues
five minutes

Write and memorize a monologue for the commedia. Clarify objectives, actions, and shifts. Incorporate a prop and activity, as needed. Next, select a stock mask that does not fit your perception of the monologue—miscasting encourages original choices. Allow the Hu-Mask to dictate your staging and line delivery.

1. Drop into mask, costume, wig, hat, and prop.
2. Look into mirror. Statue and find your voice. Speak first line of the monologue.
3. Turn to audience and initiate monologue.
4. Make your points as you speak.
5. Look into the mirror. Statue.
6. Repeat one line of the monologue. Statue again.
7. Drop out of mask.

Discussion
- Were you able to remember the monologue in mask?
- How did meaning and context change?
- What surprises did you encounter? How did they affect your delivery?

Exercise 4.28: Scenes for Three

ten minutes

Write a new scene featuring three Hu-Masks in the commedia. Each actor must memorize the scene word for word. Allow staging and actions to evolve in mask. Select props that serve the scene. Allow the Hu-Masks to alter your staging and line delivery.

1. Actors drop into mask, costume, wig, and hat.
2. Gather props as needed.
3. Statue and walk.
4. Begin scene.
5. Let staging develop spontaneously.
6. Complete scene and return to mirror. Statue.
7. Drop out of mask.

Discussion
- Were you able to remain truthful and pursue objectives?
- What surprises did you encounter?
- Did the masks create the scene (or did you think your way through it)?
- How would you improve the scene for future rehearsals or performances?

Repeat this exercise with different masks and activities.

PUTTING IT ALL TOGETHER

Mini-commedias should not be saddled with complex plots. You can string together active moments with slender slices of logic. Simple plot devices work best. Introduce new Hu-Masks to propel the plot forward. Replace Hu-Masks that do not serve the action or lack intrinsic entertainment value. Incorporate new scenes and monologues daily. Retain what works. Do not become overattached to specific Hu-Masks or lazzi. Be brutal in assessing cuts. Toss out Hu-Masks that bog down the plot, are sloppily executed, or cannot get a laugh.

Thematic Suggestions

- Begin with a theme song.
- Limit the play to eight short scenes.
- Find a strong beginning, middle, and end for each scene.
- Actors play multiple Hu-Masks.
- Add simple entertainments—individual or paired lazzi—between scenes.
- Incorporate monologues, as appropriate.
- End with a song. Invite the audience up to dance.

1. Drop into masks and perform scenes for the ensemble.
2. Vote on scenes that are worthy of inclusion.
3. Line up eight scenes that follow a semi-logical order.
4. Rehearse the scenes several times in masks.

Exercise 4.29: Theme Song
forty-five minutes

Work together to write the lyrics for a commedia theme song. If you cannot compose an original melody line, steal a familiar refrain.

1. Practice the song out of mask.
2. Elect the least qualified leader to serve as conductor.
3. Add musical instruments—kazoos, whistles, banjos, drums—as appropriate.
4. Drop into masks and practice the song.
5. Let the song evolve spontaneously.

Discussion
- Does the song work?
- What instruments should be added to round out the sound?
- Elect a new band leader, if necessary.

Exercise 4.30: Practicing in the Studio
one hour

Take a few minutes to review the order of your commedia. Write down scenes, monologues, and interlude lazzi. Then, run through the play from beginning (theme song) to end (finale and audience dance). Keep the running time between twenty and thirty minutes.

Sample Commedia
Here is the preliminary running order for twelve actors in "Surf's Up," a modern commedia adventure story:

1. Theme song.
2. Actor 1: Juggling lazzi.
3. Scene 1: Young surfer dudes meet and argue about who is a better surfer.
4. Actors 2 and 3: Bubble-blowing lazzi
5. Scene 2: Nerdy lifeguards dance in and announce that surf's up. Everyone heads to the water.
6. Actor 4: Rodeo lazzi.
7. Scene 3: Several dudes and dudettes surfing the waves (standing on chairs). They vie for the best waves.
8. Actors 5 and 6: Sing a song about surfing.
9. Scene 4: On the beach. Bikini girl and boy come prancing by. Surfers make fun of them.
10. Actor 7: Ukulele lazzi—musical interlude.
11. Scene 5: Bikini girl and boy are kung fu experts. They knock everyone out.
12. Actor 8 and 9: Duo synchronized dance.
13. Scene 6: Worried parents run in and find their children knocked out. They scream for help and run around in circles.
14. Actor 10: Carrot-eating lazzi.
15. Scene 7: Magic man/woman comes in with a potion to restore the surfers and delivers monologue.
16. Actor 11 and 12: Plate throwing lazzi.
17. Everyone is revived, dances for joy, and synchronizes surfs.
18. Theme song finale on surf boards. Audience is invited on stage to dance.

Discussion
- How can your commedia be improved?
- What lazzi can be added?
- New ideas, inspirations, and tricks.

Exercise 4.31: Back on the Streets Again
one hour

As well you know, in order to test the validity of your burgeoning commedia you must give it a trial run—live. You will quickly learn which ideas merit laughter, applause, or silence. Give each scene and lazzi your best effort. Be brave. Connect with the audience. Listen to responses.

1. Review the current running order.
2. Drop into masks in the studio.
3. Spend three minutes reconnecting with hats, wigs, props, and activities.
4. Hu-Masks walk, skip, or run to outdoor performance area.
5. Spend several minutes busking a crowd.
6. Once the audience is gathered, immediately sing the theme song.
7. Perform the scenes, monologues, and lazzi.
8. Finish with theme song.
9. Hu-Masks bow. Exit to studio.

Discussion
- Were you able to sustain the Hu-Masks from busking through curtain call?
- Which scenes, monologues, and lazzi worked best?
- Share ideas for further strengthening the commedia.

Exercise 4.32: Adding Lazzi

As you continue to perform your commedia outside, test each Hu-Mask's lazzi. These are golden opportunities to deepen your inherent

ability to entertain. If a lazzi doesn't receive laughs or applause, revise it. Minor revisions often yield magnificent results.

You will undoubtedly walk that fine line between dumb ideas and brilliant theatrical moments.

1. Between scenes, Hu-Masks perform specialty act.
2. Listen for audience response.
3. Repeat anything that prompts a laugh, groan, or gasp.
4. Continue to repeat moments until they have run their course.
5. Take a bow, then try the lazzi once more before you exit.

Discussion
- What discoveries did you make about lazzi?
- How can they be folded into the commedia?
- Do these lazzi work best as solo or duo acts?

IN CONCLUSION

Once your Hu-Masks are in high gear—firing lazzi, interacting with other Hu-Masks, and building rapport with non-masked people—you will be hard pressed to curtail the development of original masked entertainments. Potential for growth magnifies each time you drop into mask. As with joke telling, the moment *you* become bored (usually by telling the joke too many times), your audience loses interest too. Vanquish monotony by reinvesting in impractical ideas. Remain forward-thinking. In other words, commit yourself to creating new stories, retooling old lazzi, nurturing innovative Hu-Masks, and incorporating original monologues, songs, and dances. Go to the nearest bridge . . . busk a crowd . . . and get to work.

Appendix

JOURNALING: HU-MASK CHARACTERS

Hu-Mask number:

Name: Age: Gender:

Key triggers:

Facial characteristics:

Physical characteristics

 Head: Hands:

 Feet: Torso:

 Shoulders: Other:

Walk:

Gestures:

Voice:

Language:

Central Need:

Doing or activities:

Relationship with other(s):

Emotions:

Thoughts:

Environment or surroundings:

Additional thoughts:

The recipe that follows yields light, durable, and long-lived masks. They are actor-friendly. These are not leather masks such as those constructed by the famous Italian Sartori family. But, unlike their leather cousins (created over several weeks with repeated hammering, soaking, hammering, drying, hammering, sanding, hammering, dyeing), these are painless to design and build. The original members of my full-face family are now twelve years old. They have been used by hundreds of actors in classes and workshops across America, as well as in Italy and Spain. During years of heavy use they have required only minor repairs—a new headband here, a touch of paint there.

Designing the Masks

Use common sense when designing your masks. Sketch ideas before moving to the construction phase. These masks enjoy exaggerated features—an oversized nose, big moles, or bushy eyebrows. Acting masks are either symmetrical or asymmetric. Character masks are better served by asymmetrical features.

Your eyes must be visible behind the mask. Make sure that the eyeholes are large enough to permit you to see out and others to see in.

Basic designing tips:
- For older masks, add wrinkles and sagging skin.
- For younger masks, keep the skin smooth and taut.
- For aristocratic masks, use finer features.
- For powerful masks, use high cheeks and brows.
- For complex masks, combine a multiplicity of features.
- For simple masks, maintain a basic design.
- For intelligent masks, add an extra high forehead.
- For inquisitive (nosey) masks, design a longer nose.

As you can see, common sense prevails. In any event, you will not be able to ascertain the exact nature of a given mask until you put it on and are transformed into a Hu-Mask. Even the most meticulously designed masks yield surprising results. Sometimes a mask winds up with qualities you never intended. Indeed, intriguing masks often arise when the implementation of a well-conceived design goes awry. Experience and practice helps ensure positive mask building results.

Building the Masks

My masks are made with Celluclay. This substance can be bought at your local arts and crafts supply store. Celluclay is a premixed papier-mâché product. It is packaged in a powdery form. Just add water, stir, and it's ready to use.

A note: Once you begin making masks, you will find that it is just as easy to construct five at once as it is to build them singly. You just have to mix more Celluclay and prepare extra positive molds. Be forewarned: Building masks is highly addictive.

1. Create a positive mold of a face slightly larger than your own. This face can be fashioned from an old mask (plastic neutral masks work well) and built up with newspaper, cardboard, and tape. I use lots of masking tape and crumpled paper for the nose, brow, chin, and cheeks.
2. Cover this positive mold with aluminum foil. Make sure the foil is wrapped around the base of your mold so that it will not pry loose.
3. Put one cup of Celluclay in a large mixing bowl or bucket.
4. Add a quarter of a cup of water.
5. Stir the water so that it is absorbed into the Celluclay.
6. Add more water as needed until you have a thick, workable substance.
7. If your mixture is too watery simply stir in a bit more Celluclay to stiffen it up.
8. Using your fingers or a flat knife, spread the Celluclay onto the foil. The mask you are building should be a quarter to a half inch thick.
9. Leave holes for the eyes and mouth.
10. Make sure the basic shape is asymmetrical.
11. Let the mask dry. This usually takes a bit of time. Be patient.
 - If you have time: Dry your masks in the sun. This usually takes several days.
 - You can bake your masks in an oven at 75 degrees. Be careful if your oven runs hot (especially if you have paper or plastic foundations). Baking tends to shrink masks more than sun drying. Baking takes four to five hours.
 - You can also use a hair dryer to accelerate the process.
12. When the mask is dry, carefully peel away the aluminum foil.

13. Mix some more Celluclay and add details such as eyebrows, wrinkles, cheeks, etc.

14. You can add details in stages. Some of my noses and moles are built up over four or five separate applications.

15. When the mask is completely dry, front and back, sand sharp edges, smooth the inside, and/or add more details.

16. Cover the open mouth hole with black screen or mesh. Glue the mesh to the inside of the mask with strong cement. Allow cement to dry overnight.

17. After you have completed detailing the mask, apply paint. I use water-based craft paints—they're mixable and easy to clean. Celluclay accepts all paints including oils. For dynamic full-face masks, use a base coat of gray merged with one other color. Toned down shades of blue, red, yellow, and green work well. Each member of your family should have distinctive shapes, features, and colors. Keep your paint scheme simple.

18. Sew on elastic bands or punch small holes near the edge of the upper cheek with scissors, pass the bands through the holes, and tie them off. You might wish to attach the elastic bands to fishing line that is attached to the masks. This hides bands from view—the mask appears to be magically suspended on your face.

BUILDING HALF-FACE MASKS

Leather masks are ideal for commedia. As you begin to sweat, they become pliable, melding into your skin, accepting the nuances of your face. Once this new layer of skin drops into you (and you to it), the mask takes over your spirit and soul. Unfortunately, leather masks take weeks to build (if you know how to build them); they must be shaped, stretched, hammered, and stained in a painstaking manner. If you know someone who is willing to donate or loan a set of leather masks, drop to your knees and beg without shame. Otherwise, expect to spend a long time hammering away in your garage, or a small fortune to purchase a functional set.

In lieu of leather, your best bet is either papier-mâché or Celluclay. These are less complex and expensive than leather. Once you get the hang of Celluclay, you can build a wonderful family of half-face masks in a matter of days.

The lower edge of a typical commedia half-face mask rests beneath the nose. This edge can indicate the bottom of your nose or your upper lip. Either way, your mouth, jaw, and chin are unencumbered. Thus, you can vocalize freely. This is one of the reasons that commedia masks tend to verbalize more than full-face masks (where the mouth is covered).

Designing the Masks

It's a good idea to have a wide range of characters in mind when you begin assembling your family of half-face masks. For starters, here are four universal stock characters:

1. Ancient woman/man *Multiple wrinkles, bags under eyes, sunken cheeks.*
2. Strong woman/man *Strong features, healthy lines, proud cheeks.*
3. Young girl/boy *Rosy cheeks, smooth skin, pert nose.*
4. Sexy woman/man *Arching eyebrows, rosy cheeks, full red lips.*

These correlate to universal stock characters. You can build in qualities such as shrewdness, silliness, worldliness, or weirdness. Remember that when you build half-face masks, alternate qualities will appear. There is not much you can do to avoid this; it is an unwritten law of mask building. Also, keep in mind that most half-face masks will change gender when wigged.

Building the Masks

Please see instructions for building full-face masks with Celluclay, above. Instead of extending the mask to below the chin, create a lower edge below the nose—either between the nose and upper lip or including the upper lip itself.

Painting the Masks

After you have completed building the masks and the Celluclay is dry, apply paint. Each member of your family should have distinctive shapes, features, and colors. Dynamic half-face masks use a variety of bright colors. Blue, red, purple, yellow, and green work well. Use secondary colors to blend or contrast.

Finally, spray the mask with a high-sheen, clear, protective varnish. This enhances the features, brightens the colors, and protects the skin of the mask from scratches.

BUILDING BAG MASKS

1. Find a common paper grocery bag that fits comfortably over your head.
2. Shorten the bag so that it rests on your shoulders.
3. Stabilize the bag by weighting the bottom edge.
4. Reinforce the sides with cardboard strips (six-packs work well).
5. Make sure the bag is stable when you turn your head from side to side.
6. Cover printed lettering and seams.
7. Design facial features boldly.

Advice for Bag Builders

- For facial features, use bold-colored markers—black, deep blue, red, purple, or green.
- You may wish to incorporate a theme that accentuates the nature of the character. Themes sharpen the mask's features. For example, a little child can be augmented by pieces of food around the mouth or a bit of dribble on the chin. An elegant lady might have earrings, rouged cheeks, and bright red lipstick. Follow your primary artistic inclinations.
- You can glue on additional items that relate to the character: paper clips for eyebrows, string for hair, and candy for eyes.
- If you are claustrophobic, cut off the top of your bag. This will permit light and air to circulate inside the bag.

About Eyeholes

You can create bags with or without eyeholes. It's best, however, to begin *without* them. Working "blind" forces you to concentrate on the physical and vocal demands of the character. This enables you to trust your preparatory work and perform with moment-to-moment specificity. Audience reaction

(unlike in clowning and half-face masking) does not make or break your acting choices. You'll have time enough to incorporate laughs during repeat performances. For starters, focus on precisely played actions.

Recommended Reading

Appell, Libby and Watts, John R. *Mask Characterization: An Acting Process.* Carbondale, IL: Southern Illinois University Press, 1982.

Chekov, Michael. *To the Actor.* New York: Routledge, 2002.

Cohen, Robert. *Acting Power.* New York: McGraw-Hill, 1978.

Cohen, Robert. *Acting One.* New York: McGraw-Hill, 2003.

Eldredge, Sears A. *Mask Improvisation for Actor Training & Performance: The Compelling Image.* Evanston, IL: Northwestern University Press, 1996.

Fo, Dario. *The Tricks of the Trade.* London: Methuen Publishing, 1991.

Gordon, Mel. *Lazzi: The Comic Routines of the Commedia Dell'Arte.* Baltimore, MD: Performing Arts Journal Publications, 1983.

Grotowski, Jerzi. *Towards a Poor Theatre.* Portsmouth, NH: Heinemann.

James, Thurston. *The Prop Builder's Mask-Making Handbook.* Cincinnati, OH: F & W Publications, 1990.

Johnstone, Keith. *Impro: Improvisation and the Theatre.* New York: Theatre Arts Books, 1989.

Lattimore, Richmond. *Euripides III: Hecuba/Andromache/The Trojan Women Translated.* Chicago: University of Chicago Press, 1985.

Nicoll, Allardyce. *Masks, Mimes, and Miracles.* Reprint. New York: Cooper Square, 1963.

Rudlin John. *Commedia Dell'Arte: An Actor's Handbook.* New York: Routledge, 1994.

Sivin, Carole. *Maskmaking.* Worcester, MA: Davis Publications, 1986.

Spolin, Viola. *Improvisation for the Theatre.* Third Edition. Ed. Paul Sills. Evanston, IL: Northwestern University Press, 1999.

Stanislavski, Constantine. *An Actor Prepares.* Trans. Elizabeth Hapgood. Reprint. New York: Theatre Arts Books, 1989.

Stanislavski, Constantine. *Preparing the Role.* Trans. Elizabeth Hapgood. Reprint. New York: Theatre Arts Books, 1989.